PAINTING IN OILS
AND WATERCOLOUR

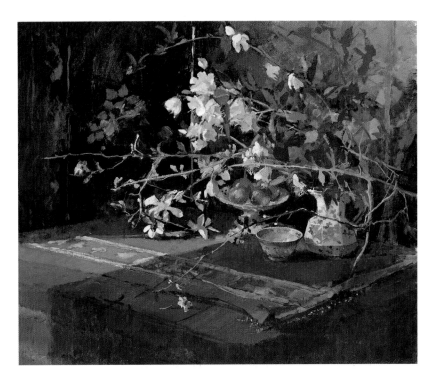

A personal view

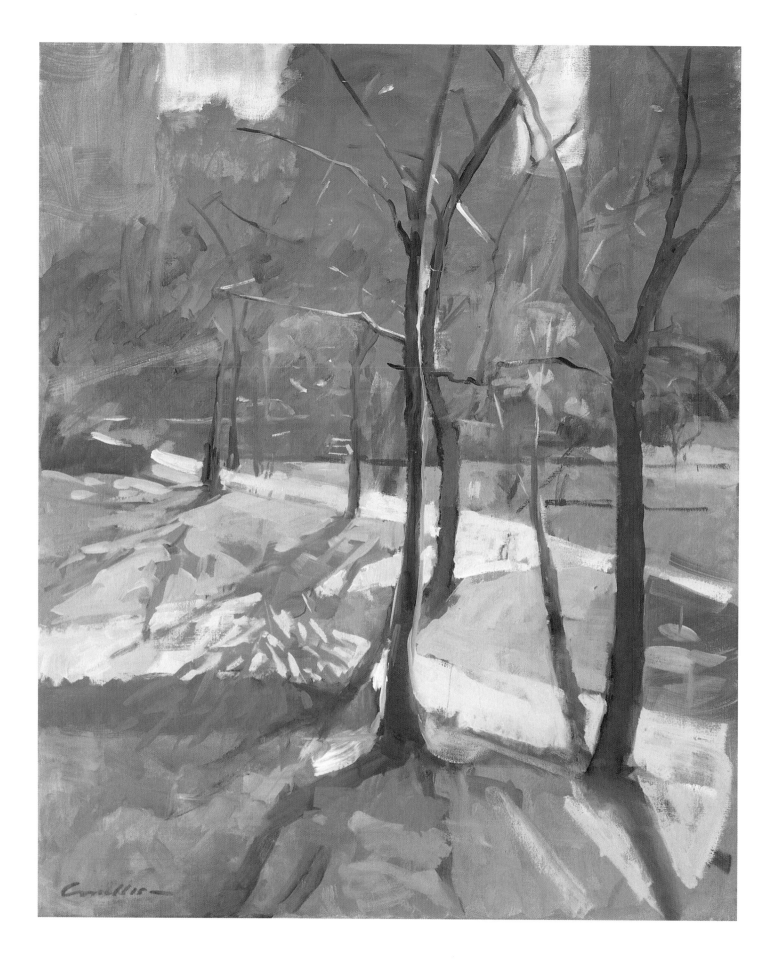

JANE CORSELLIS

A personal view

PAINTING IN OILS
AND WATERCOLOUR

JANE CORSELLIS
WITH ROBIN CAPON

David & Charles

A DAVID & CHARLES BOOK

First published in the UK in 2000

A catalogue record for this book is available from the British Library.

ISBN 0 7153 1110 7

Printed in Singapore by C.S. Graphics Pte Ltd
for David & Charles
Brunel House Newton Abbot Devon

Publishing Director Pippa Rubinstein
Commissioning Editor Anna Watson
Art Editor Diana Dummett
Desk Editor Freya Dangerfield

Although every effort has been made to provide accurate
measurements for the paintings illustrated, it has been
necessary, in a few cases, to resort to approximation.

Page 1
EASTERN STILL LIFE
Oil on canvas, 71 x 81.5cm (28 x 32in)

Page 2
WINTER TREES, CENTRAL PARK, NEW YORK
Oil on canvas, 81.5 x 66cm (32 x 26in)

Page 5
AFON NANHYFER, PEMBROKESHIRE
Oil on canvas, 91.5 x 122cm (36 x 48in)

CONTENTS

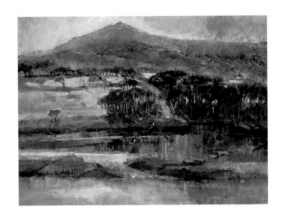

INTRODUCTION

THE LAKE AT ROHET,
RAJASTHAN, INDIA
*Watercolour and body colour,
20.5 x 46cm (8 x 18in)*

*Here I stayed in a hotel that
was formerly a grand hunting
lodge. It was surrounded by a
small, wonderfully peaceful
village and I was pleased to
have the opportunity to paint
the daily ritual of community
life before it changed. This is a
very special painting for me
and I have kept it as a memory
of my time spent in Rajasthan.*

In my view one of the most important qualities in painting is that of individual interpretation. I believe every artist should have something different to say and their own way of saying it, for it is originality and variety that makes painting so absorbing and enriching, both to artists and to the many people who enjoy visiting galleries and collecting pictures. For me the subjects that most appeal are landscapes, interiors, still lifes and portraits, though I could argue that there is only one interesting subject – light. I have always been fascinated by the way light, in all its forms and guises, influences the subject matter and adds interest and impact. My overriding concern in any painting is to capture the particular quality of light, using this to reveal my observations and thoughts about the model, objects or scene before me.

Essentially I am a figurative painter. My subjects are real and painted at first hand, and I aim to depict them in a recognizable way. However, I would describe my type of figurative work as representational rather than realistic, because I am not worried about absolute accuracy. An emotional response is just as important to me as creating a likeness, and I try to combine both these elements in my paintings.

To paint with feeling it is essential to experience the subject, and in this respect I like to work as much as possible on site, invariably beginning with sketches and studies to help me explore different ideas. The preparation for a large project might involve an extensive sequence of preliminary work that includes information in a sketchbook, drawings and photographs, as well as watercolour and oil studies. All my interiors, still lifes and portrait paintings are worked directly from the subject, and while my landscapes rely more on studies and studio work, I nevertheless do as much of the initial painting as I can on location, and often transport the canvas to the site a number of times during the painting's development.

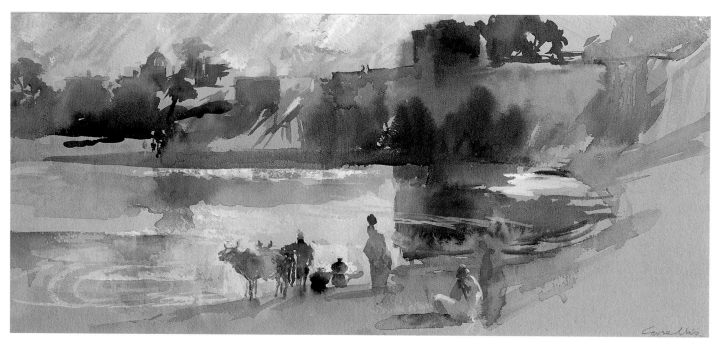

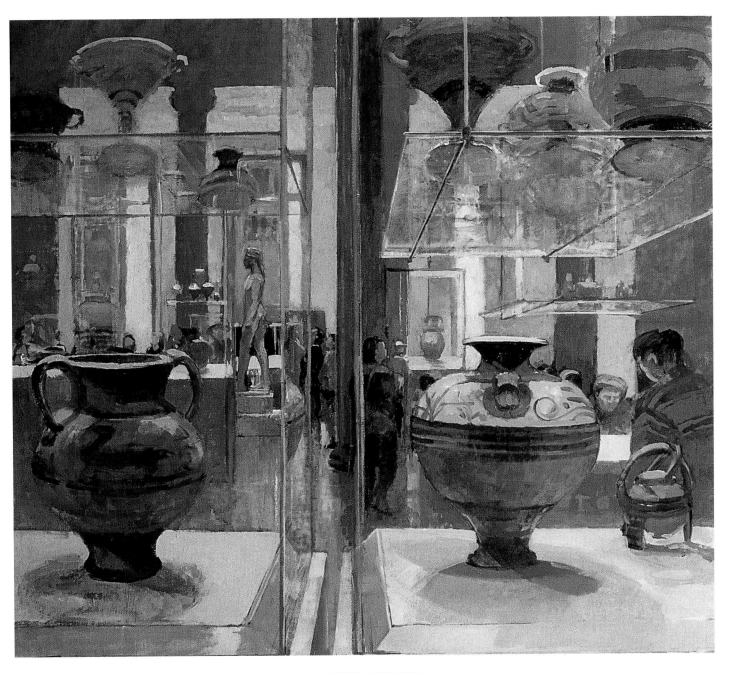

INTERIOR, METROPOLITAN MUSEUM, NEW YORK
Oil on canvas, 76.5 x 76.5cm (30 x 30in)

*When I was in New York in February 1999 I spent some time in
the Metropolitan Museum. Here I became interested in the people
looking at objects inside the glass cases, eventually deciding that
this idea would make a good subject for a painting. I was able to
make several small oil studies on the spot and used these later for
this studio painting.*

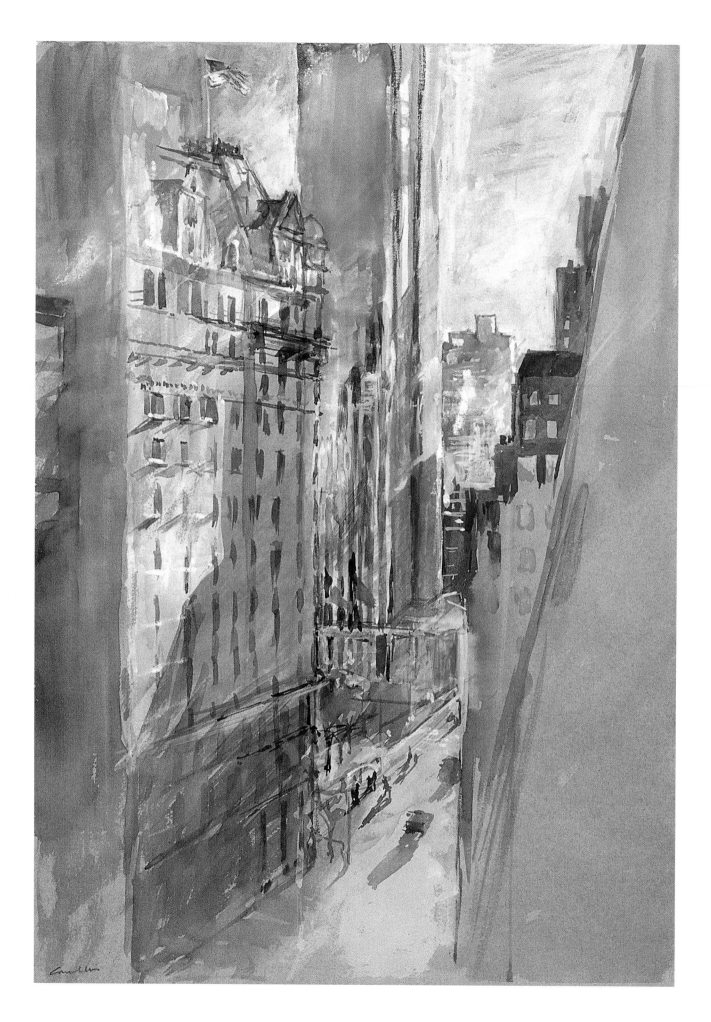

8

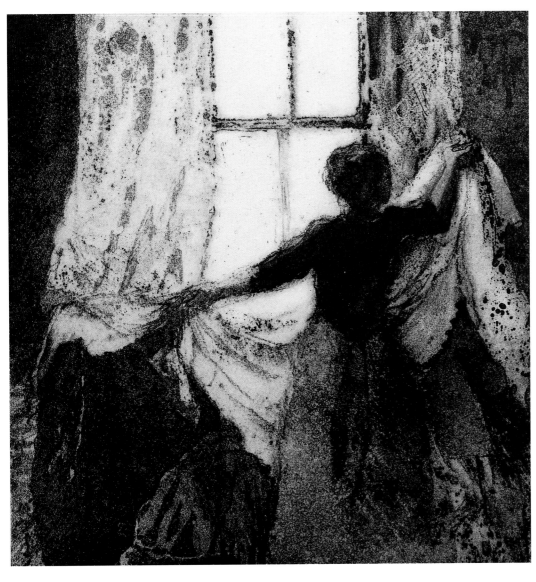

Why do I paint? I have always felt the desire to paint and express my ideas in this way, so I suppose I have never questioned why, except perhaps when a painting is going badly! But whenever I see something that strikes a chord in me I just know I want to translate it into a drawing or painting, to put my response to it down on paper or canvas. If I were a musician or writer I would do the same in music or words. It is all about observation and feeling and how one wishes or is able to interpret these. I sometimes say I paint because I cannot do anything else, but the truth is I do not want to do anything else. This is not to say that I do not have other interests, just that I am pretty single-minded about painting – obsessed maybe!

Something I discovered very early in my career was that to be a successful painter required a firm resolve and total commitment. Now, in the light of experience, if I were asked to list some qualities that aspiring painters need I would certainly include dedication and perseverance, for I cannot believe that a half-hearted approach could ever engender the skills and confidence necessary to paint with conviction and satisfaction.

I think tenacity and perseverance are particularly valuable qualities to rely on when a painting runs into difficulties. Here, my general advice is to tackle problems rather than start a fresh picture, because one can usually learn a great deal about the medium, a technique, composition or whatever, by so doing. Sometimes when there are problems I find that I can work at the painting with confidence, because I can see exactly what is wrong. However, more often than not it is a question of continually adjusting the paint

surface until some quality emerges that I like and can start to build on. I rarely discard a work, but as a last alternative I will cover the whole canvas with a thin wash of white so that the image is just discernible, put it away to dry, and then try a different approach to develop the idea.

My inspiration and motivation, as I have implied, come from observing qualities of light. I think various factors can contribute to encouraging an artist to start a painting, although inspiration striking like a bolt of lightning is not one of these! I often come across subjects that I immediately want to paint, but equally I can have an idea at the back of my mind for a long time, mulling it over and over before finally committing it to paper or canvas. To paint well, I would say, relies on being as true to yourself as possible – in other words only painting those ideas that move and impress you, and doing this in a way than enables you to express fully what you feel about the subject. To become too conscious of an audience or, perhaps worse, of a particular market for your work can only be detrimental, I believe. Nevertheless all painting is a form of communication and I am obviously pleased and encouraged if my paintings are appreciated and enjoyed by others.

I love variety: I like to work in every medium possible and paint whatever subjects interest me. I do not believe this necessarily makes me 'a jack of all trades and master of none', for I find that tackling a breadth of ideas keeps my work fresh and moving forward, and a knowledge of one medium invariably helps progression in another. For instance, I found that the process required for making an etching opened up a new development in my painting. With etching one has to think logically stage by stage; it has to be planned ahead to some extent and cannot be purely instinctive. Subsequently this approach proved very helpful with watercolours. In the same way, I found watercolour an inspiration when using aquatint in etching. I like all types of printmaking and I particularly enjoy working at lithography at Curwen Chilford Studios, where Stanley Jones guides my progress. Of course, my main media are oils and watercolour. Again, I find these support and complement each other in many of my subjects and ideas. For example, sometimes I begin with a watercolour study as a means of exploring an idea before I start in oils, and sometimes it is the other way round. Also, while I mainly use oils, I do find that the light and mood of some subjects is best interpreted in watercolour.

In learning to paint we glean tips, advice and ideas from a variety of sources, gradually discovering and developing our own way or style. I welcome the opportunity to share my views about painting and I hope that as well as my thoughts on using oils and watercolour, researching and planning ideas, considering colour and light, and painting different subject matter, one of the other important aspects that will emerge is the need for careful observation. Learning to paint is as much about being taught to look at and understand things as it is about colour, composition or anything else, I believe. But it is not simply a matter of observing something and then restating it – rather, it is one of observing something and then interpreting it.

In this book I aim to show and explore the philosophy, approaches and techniques that I have developed as a professional painter. You will discover that painting does not always happen easily: that struggles are often an inherent part of the painting process. Equally, I hope you will see that painting can be immense fun and very rewarding. My method of painting is one that I have developed over years of trial and error and obviously it is a personal one. However, as you read through this book I hope you will find plenty to excite and interest you, as well as some help and encouragement in facing the challenges in your own work.

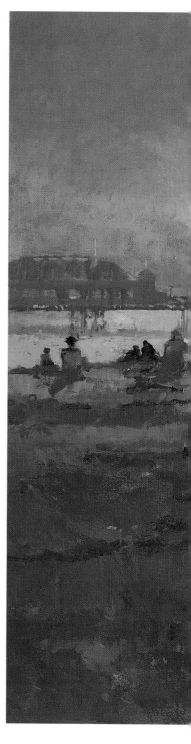

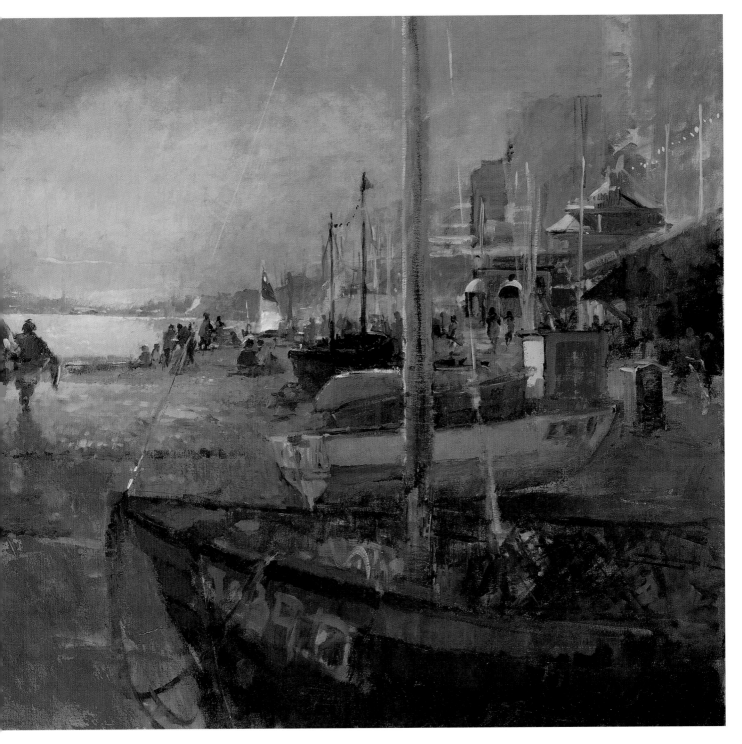

EVENING, BRIGHTON BEACH
Oil on canvas, 76.5 x 102cm (30 x 40in)

*I loved the evening life of Brighton beach, with the holiday-
makers, the groups meeting after work, and other people just
sitting alone and watching the sea. On this particular evening the
whole atmosphere was one of calm after the busy day.*

Chapter One

WORKING IN OILS

Opposite
STILL LIFE W11
Oil on canvas,
91.5 x 71cm (36 x 28in)

Because it can be applied and manipulated in all sorts of ways, oil paint is excellent for capturing particular effects of light. The initial stages of this painting were laid in with loose washes of colour and then, to achieve the special qualities of the late afternoon winter light, I rubbed in further thin layers of paint with a rag and began to develop the shadows and other dark areas with bolder brushwork.

The qualities I particularly like about oil paint are its richness and its versatility. Also important to me is the plasticity of the medium, the obvious 'feel' of the paint, and the fact that there are so many different ways of applying it. As well as brushes, I use palette knives, rags, my fingers and various other means to create a wide range of surface textures and effects, being as rough or as delicate in approach as the subject demands. Moreover, because oil paint is slow drying it can be pushed around, worked into and even mixed on the canvas. Should the results not be satisfactory, then the paint can easily be wiped off or scraped back to the dry surface beneath and the area reworked. No other medium has such a forgiving nature.

The instinctive way I now use oils has evolved from working with the medium over many years. In fact, I have painted in oils since I was a child. My mother was an artist and she encouraged me to use oil paints rather than any other medium. From the very beginning I seemed to have an affinity with oil colours and I have always enjoyed the tremendous scope they offer for different techniques and handling possibilities. For example, you can contrast opaque and transparent passages, work wet-in-wet or alla prima, adopt the traditional fat-over-lean method, or involve thin washes, blending or impasto techniques. Another attraction of oils, I find, is that having built up an understanding of and confidence with the medium I no longer have to worry about how it will behave while I am using it.

Most painters assimilate ideas from other artists and one's teachers can be a particular influence. At the Byam Shaw School of Art I was fortunate to be taught by Bernard Dunstan and the late Peter Greenham, both of whom influenced the way I use oil paint. Their method of working in patches of colour and building up a painting almost like a jigsaw is something I empathize with, as is the way they contrast delicate touches of colour that are sensitively stroked onto the canvas with strong, visible brushmarks.

I have always been influenced by Degas and Bonnard. I especially like the way Degas applied paint: he seemed to press it on. What I have learnt from these artists is that it is important to consider the actual surface quality of the painting as well as the subject matter, colour, light and so on. In my oil paintings I enjoy combining a variety of techniques and creating different textures. This helps me to express and interpret the subject matter in the best way, and it also adds interest and impact to the final work.

The type of support or surface I choose for my paintings depends on whether I am working outside or in the studio. For location studies, which are normally no larger than 20.5 x 25.5cm (8 x 10in), I paint on canvas-covered boards which are made by gluing a small piece of ready-primed canvas to a backing board of thin medium-density fibreboard (MDF) with some acid-free adhesive. I keep all the offcuts of canvas for this purpose and trim these to appropriate sizes. Alternatively, I sometimes use manilla boards. I save the

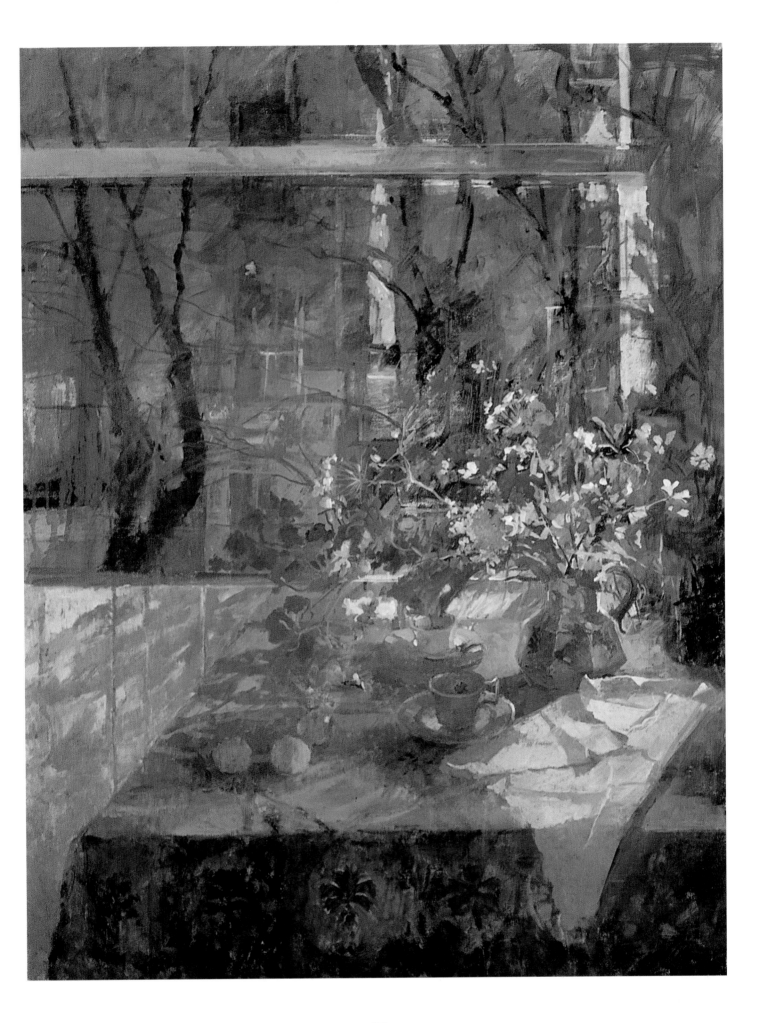

SUNLIT TABLE
Oil on canvas,
81.5 x 86.5cm (32 x 34in)

Here again light was a key element in the painting. I intentionally created a dramatic lighting effect by lowering the blinds, so that just a little sunlight could fall across the subject. Thin glazes of colour were applied one on another to build up an underpainting and the more resolved forms of the objects were subsequently developed over this.

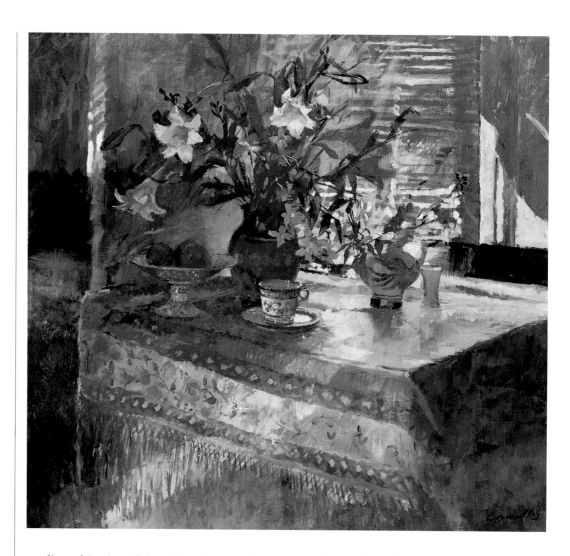

cardboard backs of sketchbooks, cut these to a variety of small sizes, and prepare them with a coat of acrylic primer. Both types of board provide a good surface to work on and, being small and lightweight, they are easy to carry around.

For the studio paintings, I work on a double-primed Belgian linen canvas which I buy in rolls from Bird & Davis. I used to prime my own canvases but eventually this became too time consuming. I have a stock of different-sized stretcher pieces and when I have decided on the size of a particular painting I stretch a canvas accordingly. Usually I can determine the shape and size I require by consulting the preliminary studies. However, sometimes during the painting process I realize that a smaller or larger size would have worked better and in that case I will either cut the canvas down or start another painting. I seldom abandon a painting. If I do make a second start, I will work on this alongside the original.

The white surface of a canvas can be very inhibiting, so I like to cover this as quickly as possible with a thin wash of paint. The colour of this initial wash, or imprimatura as it is called, is determined by the subject of the painting. Normally I will use a cool tone for a seascape and a warm tone for a rich brown still life, as this helps to tie or anchor all the subsequent colours together. But sometimes I prefer to go consciously to the opposite side of the colour circle and, for instance, use an orange base for a blue seascape, because this will produce an added brilliance. It all depends on the effect I am hoping to achieve. The

wash is made by diluting some pigment with plenty of white spirit, pouring it into the centre of the canvas and then rubbing it in with a rag. As the painting develops I make use of this underpainting, perhaps by allowing it to show through in places or by exploiting it to enrich or subdue areas.

With all materials, I think it is an advantage to work with the best you can afford. I always use artists' quality oil paints and my palette combines colours from a number of manufacturers, including C. Roberson & Co, Schmincke and Winsor & Newton. Each colour is chosen for a certain characteristic, such as density or transparency, that I prefer. I tend to use the same colours most of the time, although sometimes I will introduce Venetian red, for example, if a subject calls for it or if I feel it will mix with others for a particular grey. Occasionally I like to experiment with different or unusual colours to see what will happen.

My palette consists of flake or titanium white, lemon yellow, cadmium yellow, yellow ochre, transparent golden ochre, raw umber, burnt sienna, light or Venetian red, cadmium red, permanent rose, rose madder genuine, French ultramarine, cobalt blue, cerulean, oxide of chromium, viridian and terra verte. I lay the colours out on my palette in that order, starting with white on the right. This is the sequence of colours I have always used, and the familiarity with this layout means that I do not have to break my concentration to search for a colour. I dislike black. It is an intrusive colour and I would never consider using it on its own. I only use black when I want to mix a particular green. To get a warm green, for example, I sometimes mix alizarin crimson with a little black and yellow ochre, although I generally find an alternative method using either raw umber or French ultramarine.

White spirit is my preferred diluent or thinning agent. I have tried turpentine and other media but found that the paint would not dissolve in the way that I like. The white spirit is used for laying in colours and cleaning brushes. However, after the initial stages of a painting, which are worked mostly as thin areas of colour, I begin to add linseed oil to the white spirit to increase the viscosity and texture of the paint – in effect, working 'fat-over-lean'. Typically this mixture consists of one part linseed to three parts white

THE GOLD CUP
Oil on canvas,
30.5 x 40.5cm (12 x 16in)

For this very direct, on-the-spot still life I worked straight onto sized bare canvas – that is canvas which had not been prepared with a white gesso ground or imprimatura (preliminary thin glaze of colour). Because of the coarse tooth of the canvas, it was necessary to place or press the paint on rather than use broad, loose strokes.

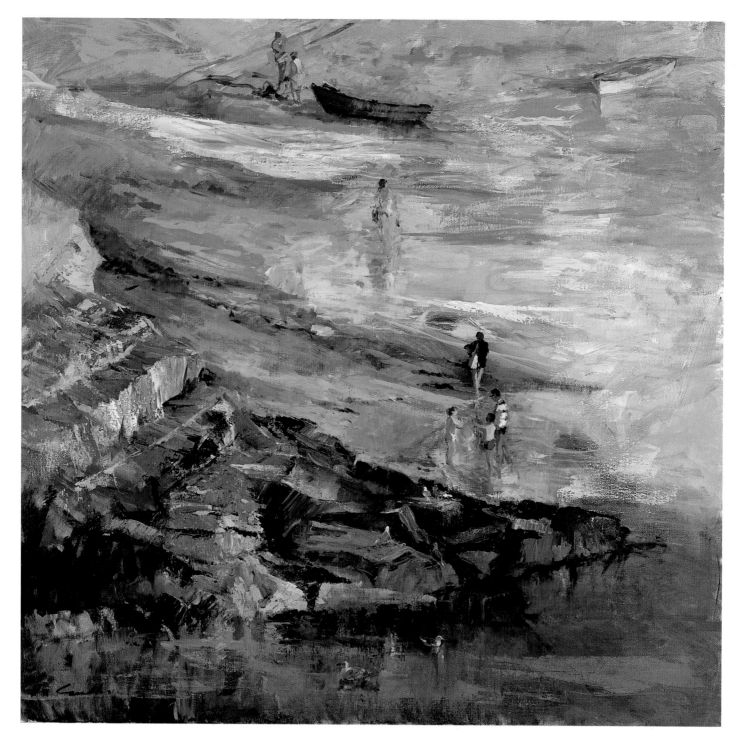

END OF THE DAY, RETURNING HOME, NEWPORT SANDS
Oil on canvas, 91.5 x 91.5cm (36 x 36in)

*This is just the kind of painting I really enjoy, with plenty of scope
for textural effects in the rocks and cliffs, and the opportunity to
contrast strong brushwork with delicate detail.*

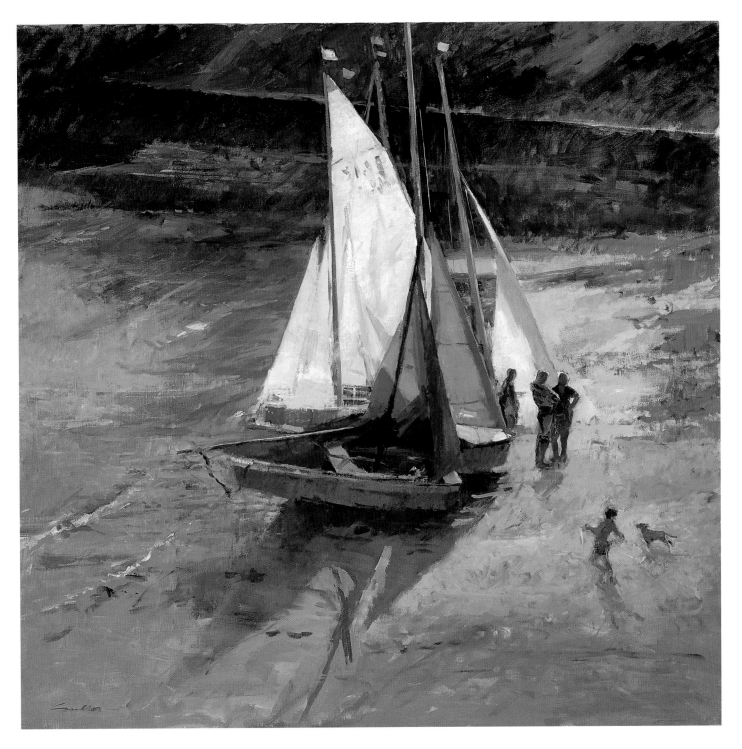

EVENING ON THE BEACH, PEMBROKESHIRE
Oil on canvas, 91.5 x 91.5cm (36 x 36in)

This is a scene I know well – one I often watch from my studio in Wales. Here, the evening shadows were constantly changing, so I decided to make some quick studies which could be used for a more resolved painting in the studio later.

INNER HARBOUR, PORTHGAIN
Oil on board,
15 x 23cm (6 x 9in)

A quick alla prima location study to help me assess the potential of this subject and observe and note down its salient elements.

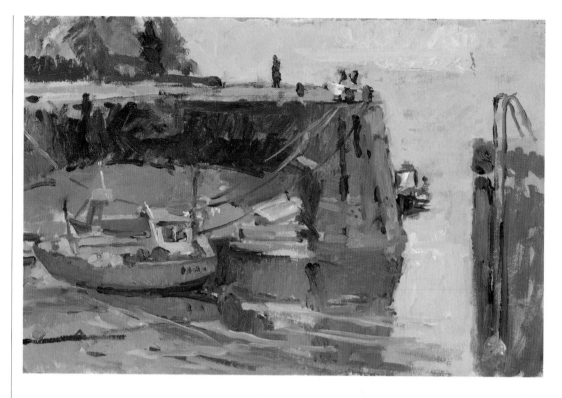

INNER HARBOUR, PORTHGAIN
Canvas laid on board,
25.5 x 46cm (10 x 18in)

An alternative study, in which I began to think about the direction of the shadows and how these might benefit the composition.

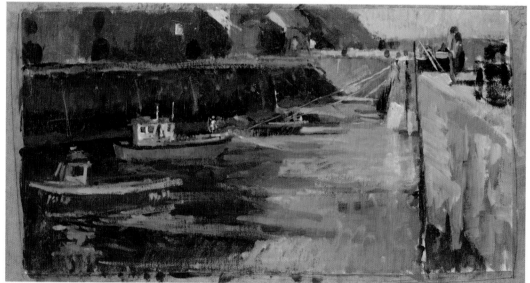

spirit, although it will vary. I do not like the paint to be too slippery in texture. Commercially produced paints can actually contain quite a lot of oil and in some circumstances they are easily applied and manipulated without the use of linseed or any other medium.

Additionally, I create my own painting medium. After each painting session I pour the white spirit I have been using into a large jar, and this is left to stand for two or three days to allow the paint sludge to separate from the white spirit. I then strain off the white spirit, which inevitably contains a certain amount of oil from the paint, and use this as a painting medium. I find it has just the sort of consistency I like for use in the middle to late stages of a painting. Finished paintings are left to dry and then given a coat of

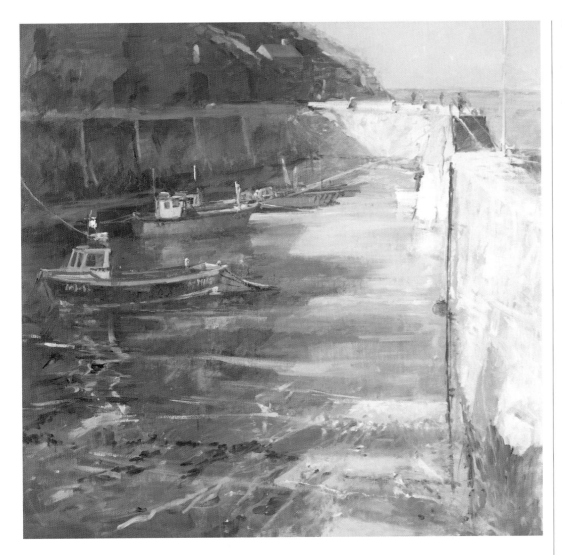

LONG SHADOWS, PORTHGAIN
Oil on canvas,
91.5 x 91.5cm (36 x 36in)

I worked mainly from the lower study shown on the opposite page, deciding that I did not want the gap in the harbour wall as this would create much too obvious a break in the composition.

retouching varnish. This enlivens those passages, particularly the dark areas, which have lost their vibrancy, and it re-establishes the correct colour balance.

I work with a variety of flat and round hog-hair brushes which I buy from L. Cornelissen & Son and C. Roberson & Co, plus some short-handled Cotman nylon brushes made by Winsor & Newton. My brushes tend to have a short life, as I treat them very roughly. Also, I really like the spring in a new brush and therefore I have to buy new ones regularly. In the studio, my mixing palette is the top of a folding table or an ordinary household wooden tray. I dislike using a conventional palette as this normally gives me excruciating arm ache, and in any case I like to hold a rag in my left hand while I am painting. When the day's painting is finished, I take a palette knife and remove the surplus paint from the mixing area of the palette. If reasonably clean, this paint is rubbed onto the small canvas panels as a base colour.

Out on location, I use a pochade box or I work at a sketching easel, box easel or sometimes a radial easel, depending on the scale of the painting and the particular circumstances. I seem to have accumulated quite a number of easels over the years, but each one serves a slightly different purpose and so I am able to choose exactly the right easel for the sort of painting I have in mind. In the studio there is a large Italian wind-up easel and a lighter radial easel, which can also be adjusted to a horizontal

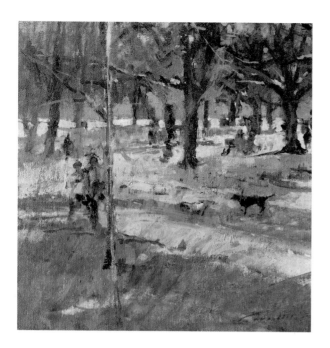

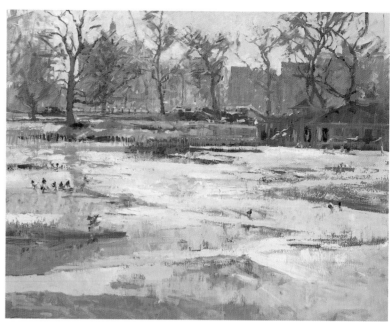

MEETING IN THE PARK
Canvas laid on board,
25.5 x 23cm (10 x 9in)

This winter study in
Kensington Gardens was one
of a number I did to search out
subjects for a series of snow
paintings. I love the park
because although it is a
landscape it always has the
added interest of people, dogs
and activity.

working position for watercolours and drawings. If I am working on several canvases at once, when painting a triptych for example, I make use of the sketching easels as well as the larger studio easels.

Before attempting the actual painting I think it is important to get to know the subject by making a number of sketches and studies. For sketching trips my equipment consists of five or six small prepared boards, several short-handled brushes, a box palette laid out with the usual sequence of colours, rag, spirit, a sketchbook, and perhaps a small watercolour box and some pencils. Most of this fits into the pochade box, and the whole lot is carried in a rucksack. Also, because I find *contra jour* work exciting, another essential item of equipment is a hat with a large brim. This helps to counteract the glare of the light.

I usually know the area I want to paint, if not the exact subject. Often I start with some really basic scribbles or what I call 'maps' in my sketchbook. Essentially, these plot the position of the main elements of the composition in simple, direct terms, sometimes just in line and sometimes in line and tone. The 'maps' provide a lead-in to the subject matter and encourage me to start an oil study on one of the small panels. I will work on this for about an hour and then try another view, perhaps a short distance away, also as an oil study. In this way, I discover exactly what I want to paint.

It is worth spending a little time exploring an idea, I believe, because this helps you decide whether or not the subject really is the one that will hold your attention over the next few weeks and lead to a fully resolved work. From all the observation and studies that have been involved, you have to decide exactly what it is you wish to say about the subject. Is it the complex composition, the atmosphere or light, the scale, or some other quality that attracts you? Whatever it is, the best approach is always to keep the initial idea simple and let the painting grow and develop from that.

My aim in these small studies is to paint what is in front of me, observing the light and shapes and not worrying at this stage about the strict composition or detail. This is not to say that I slavishly copy what I see. These small studies should just be an impression of that fleeting moment. The composition or structure of the painting comes naturally with experience, and details can be captured in careful drawings made later. I try to complete

Left
ICE ON THE SERPENTINE
Oil on canvas,
66 x 81.5cm (26 x 32in)

Even on this really cold day, when the lake was frozen over, there was something going on, with building workers in the distance and birds on the ice. I painted this from the back of the car, so the cold was not too much of a problem, and fortunately the light was fairly constant the whole day.

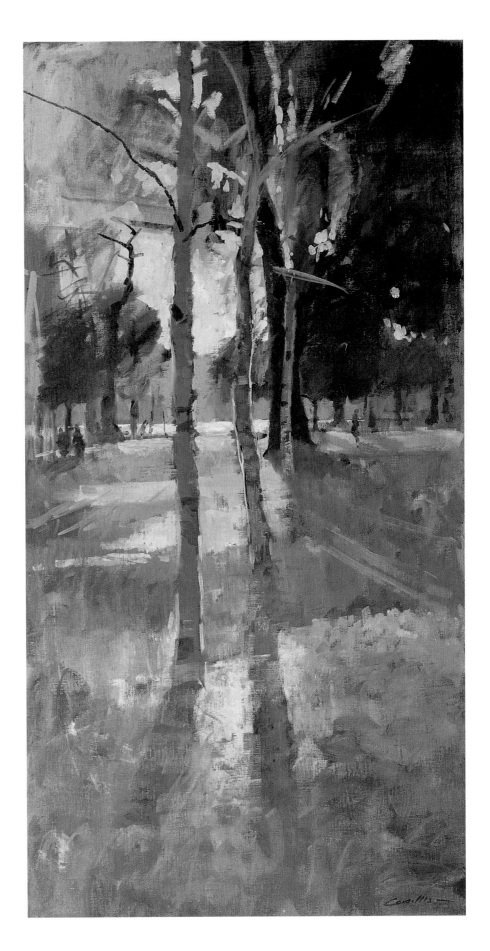

TOWARDS THE ROUND POND, WINTER
Canvas laid on board,
122 x 61cm (48 x 24in)

For this very dramatic painting, which was probably influenced by Norwegian landscapes, I chose a support made by gluing bare canvas onto a board, developing the work with passages of carefully placed thick paint, and other areas where paint was rubbed quite roughly onto the surface with a rag and bristle brush.

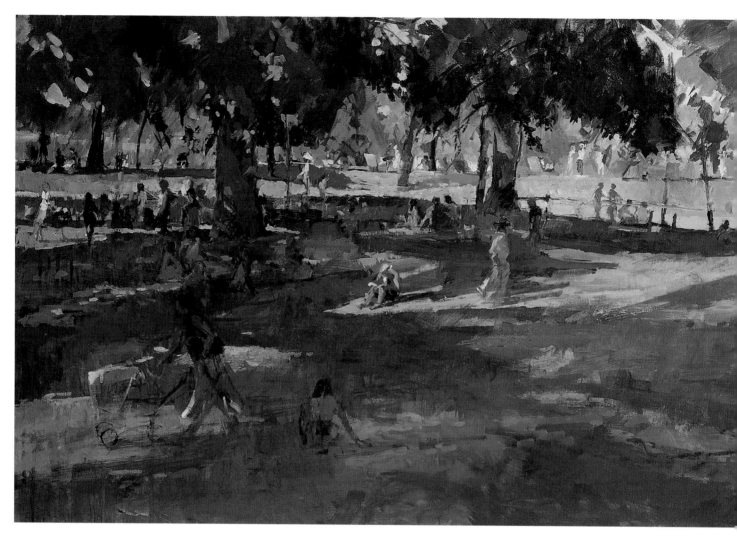

these studies in no more than two hours. If I work for longer, they start to become considered paintings rather than studies.

I work quickly, using an alla prima technique. Mostly I paint with a brush, although sometimes I will apply really thick paint with a knife. Usually the paint is mixed quite thickly, diluted only with a little white spirit. The colours are worked wet-in-wet, in a single 'take', without recourse to subsequent modification. Very occasionally I will scrape back an area and rework it, but usually there is no time to adjust or reappraise what has been stated, and in any case a considered approach is not really within the spirit of creating studies.

If a study is not successful, then I will start another. An important point to bear in mind is that these studies will normally be viewed as a body of information rather than as separate references. The final painting may well incorporate elements from a number of studies. As well as the oil studies, I sometimes paint directly from a landscape subject in a more resolved way. Here my approach is somewhat different. I start in the studio by drawing or painting in the bare bones of the subject, using information from sketchbook drawings. Then I work on the spot for a morning or an afternoon session, depending on the type of light I want. Often I combine studio and location work in this way. There are also times when I find it essential to take a painting back on location in order to view it in relation to the actual subject. This refreshes my perception of the subject and can help to solve problems that I am experiencing in the studio.

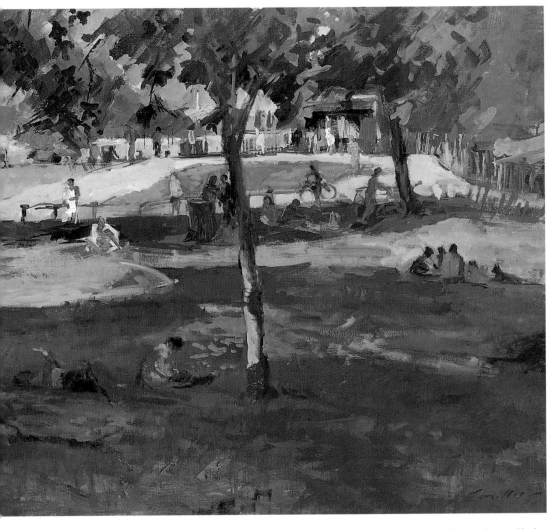

SUMMER – HYDE PARK
Oil on canvas,
66 x 168cm (26 x 66in)

Even with large paintings such as this I like to paint on site as much as possible. I carried this canvas very self-consciously through the park, although in fact nobody took any notice at all and I was able to work mainly undisturbed, but for a few curious children who asked to be in the picture. I had always wanted to compose a painting with everything going on around the sides and with an 'empty' though equally interesting centre. I think this works because of the fortunate patch of light in the middle and the direction on the shadows. I also like the way people are walking out of the painting and sitting with their backs to us. Yet these groups draw the eye into the centre, where the line of deck chairs links everything together.

When I am painting in the studio, the first thing I do is have a careful look at all the studies and preliminary work and decide on the size and shape of the painting. I display all the studies around my easel, which in a sense creates a feeling of being out on location. The time spent doing this allows me to think about the painting and focus on how I want to tackle it. Then, working on a canvas prepared with an appropriately toned ground, I start by indicating the main shapes and directions of the subject. I draw these lines in roughly, using a hog brush dipped in raw umber. Next I apply loose washes of thin colour over the whole canvas, so further establishing the principal areas of the composition and beginning to suggest colour and tonal relationships.

From then on it is a matter of battling away, trying to develop the whole painting at the same pace and not spending too long on any detail. Over the first washes of colour I begin to build up the painting in layers, using different methods of applying paint, though initially still keeping it fairly thin. I will draw and redraw with a soft round brush, which I find best for this sort of work as I can use either the fine point or drag the body of the brush for a fuller line. Often this drawing will be covered by broad areas of paint and then I will define the lines again. In this way the painting gradually acquires a 'lost and found' quality, which is something I like.

In the latter stages of a painting I become more interested in the surface quality of the paint and introduce various techniques to help develop this. I may, for example, use a flat

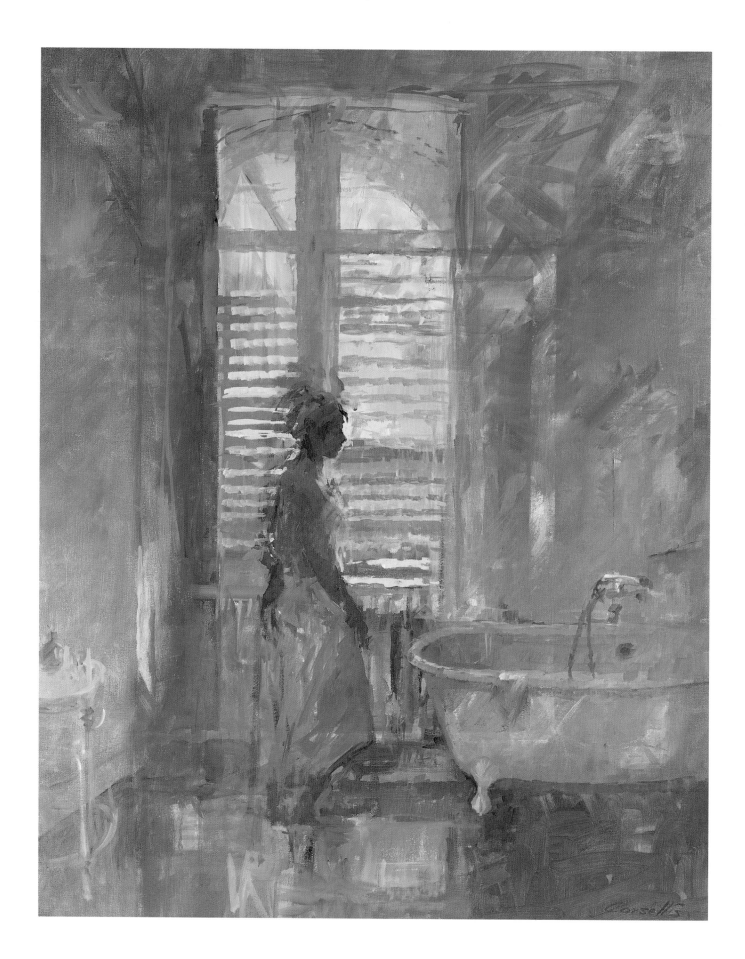

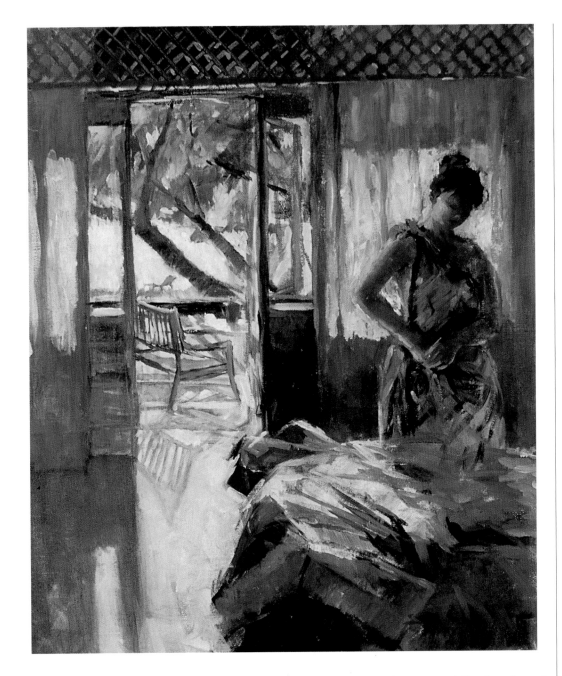

Left
BEACH HOTEL, TYING SARONG,
MALAYSIA
Oil on canvas,
46 x 63.5cm (18 x 25in)

I completed this painting while the hotel maid was making the bed, and reworked it later. As here, I sometimes like to note down a quick 'moment' and make my eyes and mind act like a camera. My training for this came from an exercise we used to do at art school. We had to look at an object and then go into another room to paint it.

Opposite
BATHROOM IN FRANCE
Oil on canvas,
80 x 61cm (31¹/2 x 24in)

I enjoyed the **contre jour** *possibilities of this subject, where the figure could be treated in quite a loose way to create a dramatic dark-against-light contrast.*

hog-hair brush literally to press fairly dry paint into a particular area, while elsewhere I might suggest a different type of texture by dragging a lightly laden brush across the painting so that it just catches the surface here and there. Such areas will contrast with others that involve blending techniques, where broad strokes of colour have been worked one into another while the paint is reasonably wet, and those that have been created with a rag or painting knife. I will often use a rag to lift off the surface of the paint slightly and then work over or into the resultant texture.

Each painting must make its own point, of course, but what I find is that ideas feed off each other, so one painting helps the next. In any event, over a period of, say, four weeks my normal practice is to work on three or four paintings together. I will spend several hours on one painting and then switch to another. I find my painting works better that way: I return to each idea fresh and eager to do more!

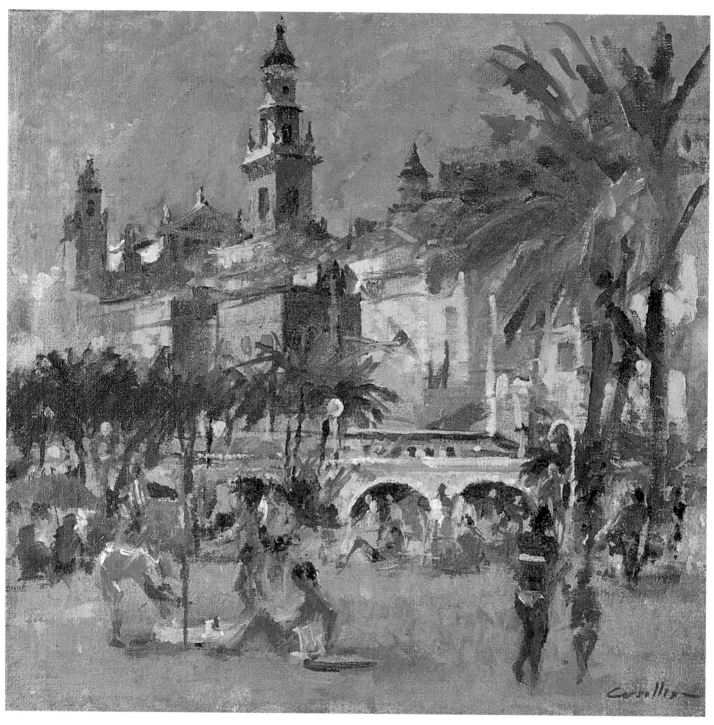

Above
THE BEACH, MENTON
Canvas laid on board, 30.5 x 30.5cm (12 x 12in)

This alla prima painting was a sheer delight. Working quickly with fairly thick paint, my aim was to capture a reminder of the colour and the Mediterranean atmosphere.

Opposite
LA PLACE AUX HERBES, MENTON
Canvas laid on board, 30.5 x 20cm (12 x 8in)

In this exploratory study I was interested in the composition possibilities of using different rectangular shapes, with the figures included to give plenty of foreground interest.

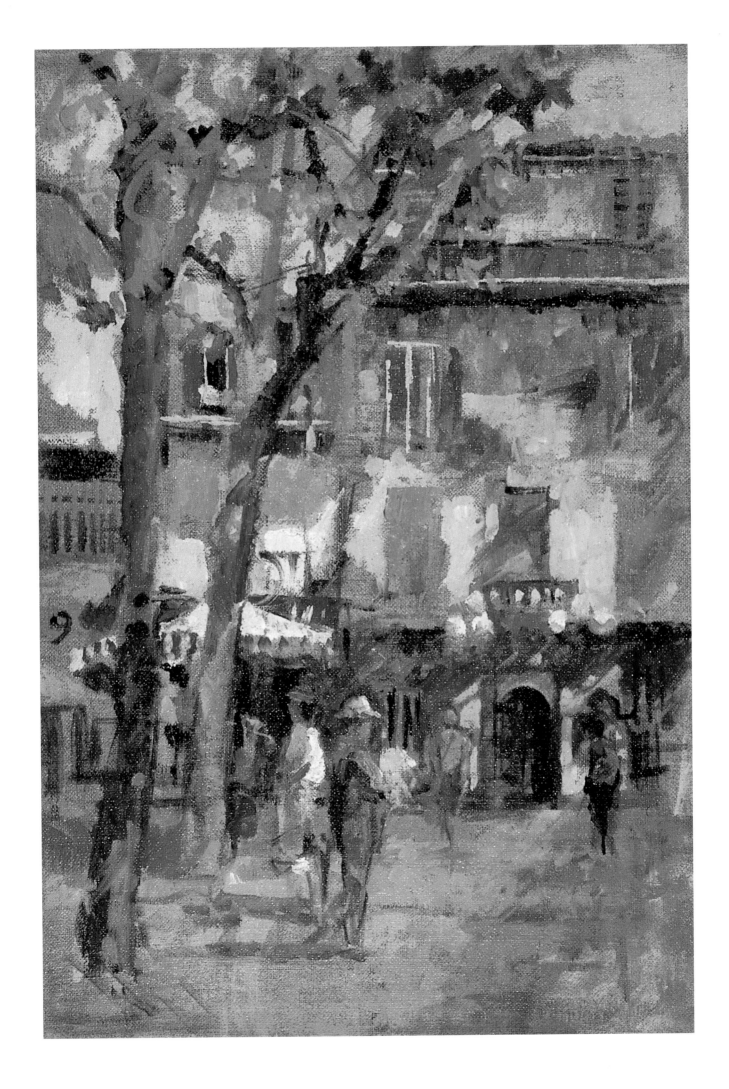

WORKING IN WATERCOLOUR

In contrast to oil paint, which can be handled in a very controlled way if necessary and is seldom beyond redemption if things go wrong, watercolour is an unpredictable medium. But this is something I find both fascinating and challenging.

Obviously in all painting, whatever the medium, there are always various unknown factors and you are never quite sure at the beginning of a work exactly how it will develop. However, the element of discovery is much more an inherent part of using watercolour than it is with any other medium. In this respect, because the intention and success of the work involve a degree of chance as well as skill, watercolour can prove a very difficult medium. Indeed, each painting seems to offer new problems and fresh challenges. Additionally, it is a fluid medium that allows only a limited amount of manipulation before the surface of the paper is damaged or the translucency of colour is lost. Consequently, there is limited freedom to correct mistakes.

This is not to say that the particular qualities of watercolour need overshadow or inhibit the way you work. These qualities have to be respected, of course, and I admit that when I paint in watercolour I have to think harder about how the medium is behaving and the likely consequences of my actions. But I find watercolour exciting and just as rewarding – although for different reasons – as painting in oils. It is particularly suitable for subjects in which mood and atmosphere are important qualities, and it is ideal for painting on location, where it is usually necessary to work fast and with an emphasis on capturing certain information or the essential characteristics of the subject.

My introduction to watercolour came after I had left art school, when I saw some paintings by Josef and Isaac Israels while staying in Amsterdam. These paintings were quite a revelation: I had not realized that watercolour could be so lively, expressive and vital. Before then I had dismissed watercolour as a possible medium, having seen only meticulously painted and rather uninspiring examples. Their unimaginative use of colour and lacklustre impact had failed to impress me. However, I had now discovered that there were some wonderfully 'fluid' painters about and I was soon studying the work of Turner, the English watercolour school, Constable, Cox and especially H. Brabazon Brabazon.

At art school my course of study was in the academic tradition and thus had an emphasis on drawing followed later by painting nudes, still life and other compositions in oil. So discovering watercolour, which in contrast was such a wonderfully immediate and lively medium, was both exciting and terrifying. I once asked a friend, Tom Coates, a brilliant watercolourist, how I should set about painting in watercolour and he gave me some very sound advice. 'Stop dithering,' he said, 'and just get on with it!' In other words, it is best to learn from your own mistakes and glory in the discoveries you make.

One thing I have learned is that despite the unpredictable nature of watercolour – or perhaps because of it – a certain amount of planning is essential. For example, before

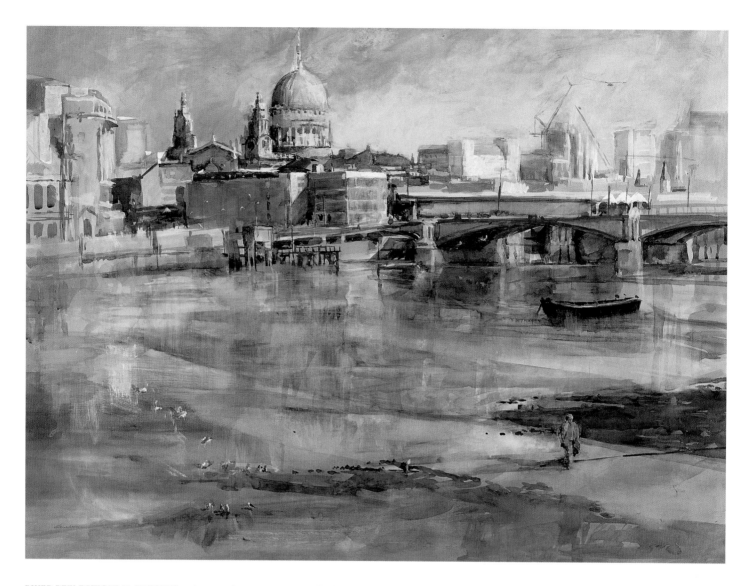

RIVER REFLECTIONS II, ST PAUL'S
Watercolour and body colour,
65 x 84cm (25¹/2 x 33in)

When I work on a tinted paper, as here, I often start by drawing in the main shapes with weak white gouache and then apply preliminary washes of white gouache before developing the painting in watercolour.

starting a painting I decide which paper to use, how large to make the painting and, if working on white paper, which areas to reserve or leave white. I have also discovered that even when one is faced with a painting that is getting well out of control and seems destined for failure, all is not lost. Drastic problems call for drastic action I believe, so I remove the painting from the board, rinse it in the bath to take off as much paint as I feel is necessary, re-stretch it, and when it is dry make a fresh start. In fact, you can keep working away at a watercolour until you go through the paper!

Like oils, I find that watercolour suits both studio and location work. Outside, I often use watercolour as a 'way in' to oil paintings and a means of exploring a subject and noting down information, as for example in the small studies shown on page 38. But this is not a practice that I necessarily keep to and sometimes I will work in precisely the opposite way, beginning with an oil study. On other occasions I know that I want to paint a resolved watercolour rather than an oil painting, because there is something about the subject, the quality of light or some other aspect that is best interpreted in this medium. *Beach Hut, Early Afternoon* on page 36 is an example of this approach.

Also, now and again, if I reach a point in my painting where I seem to be struggling and am not sure what to do next, I will discipline myself to paint some watercolours of the

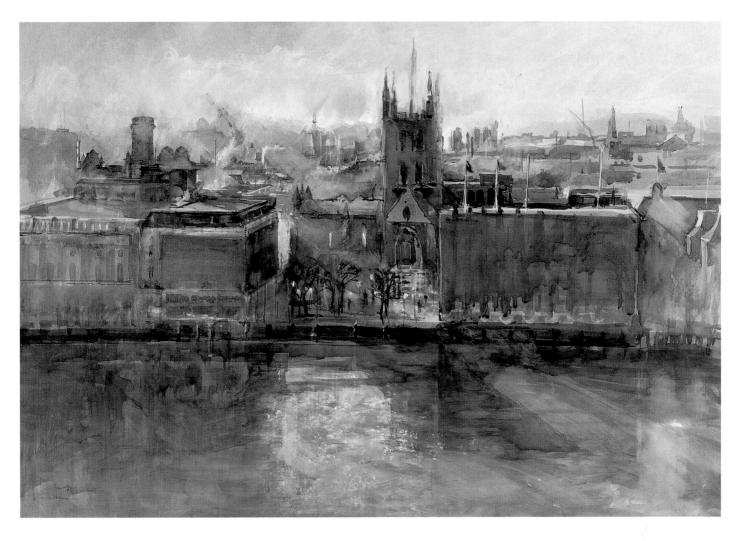

SHADOWS ON THE THAMES,
SOUTHWARK
*Watercolour and body colour,
61 x 91.5cm (24 x 36in)*

subject purely as an exploratory exercise. This was something I learnt at art school and it is a device that has proved invaluable since. I go into the studio and make a sequence of little watercolour studies, not worrying how these will turn out but just using them to find my way back into my painting.

I like to use the best possible materials and my advice to those who cannot afford a huge range of paints, brushes and so on is to concentrate on quality rather than quantity. For example, if well looked after, two sable brushes will prove a much sounder investment than several cheaper ones. Obviously paper is one of the most important materials, as its particular quality, texture and absorbency can have a decisive influence on the effects and techniques that are possible in the painting. I am very 'paper conscious' and am always buying different papers and trying them out. In consequence I have acquired a huge stock of papers, from ordinary brown wrapping paper to the most expensive hand-made papers. I love paper for its surface value as well as its working characteristics, and I experiment with a great many types in my everlasting search for the perfect watercolour painting surface.

In the main, my choice of paper is determined by the subject matter and what I see as the essential qualities to express. It depends on whether I want to brush the surface of the paper lightly or actually work into it. For a white paper I prefer T. H. Saunders' 300gsm /140lb NOT, which is also available on a roll 91.5cm (36in) wide, although occasionally I

I chose a grey/green Italian paper for this subject, which took several sessions to complete and was painted mainly on site. While I was disappointed with the regular tooth of the paper, because it made it more difficult to create loose, broken washes, I liked the fact that it stood up well to sponging and lifting-out techniques.

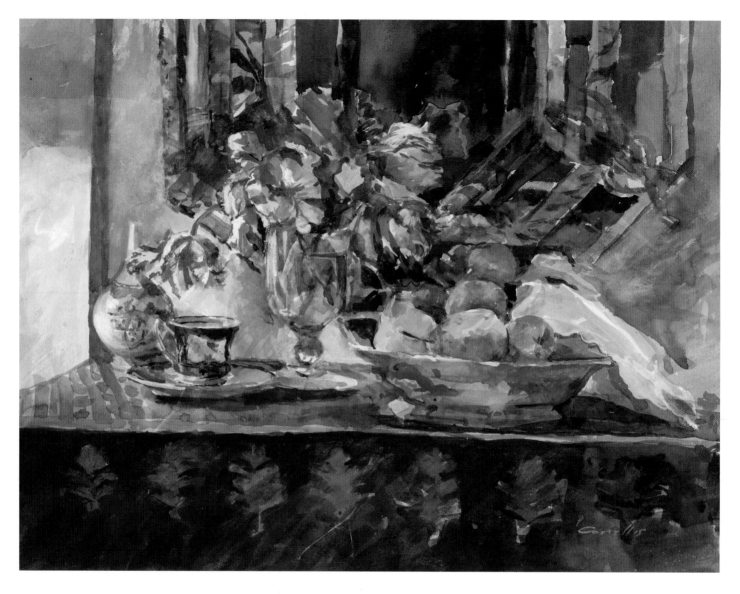

PARROT TULIPS AND VENETIAN
MIRROR
Watercolour and body colour,
33 x 40.5cm (13 x 16in)

There is a lot of sponging-out
and reworking in this
painting. To modify areas I
take a clean wet sponge, dab it
onto the painting, rinse it out
and repeat the process as many
times as is necessary to remove
the colour, leave to dry or dry
with a hair-dryer, and then
apply fresh washes of colour.

will use a heavier quality paper. The tinted papers I normally use are Two Rivers' hand-made and an old, out-of-production, Barcham Green paper, Turner grey 180gsm/90lb NOT. Recently I have discovered a new Turner grey/blue that I like, made by John van Oosteröm, a supplier in London.

I stretch all papers in the traditional way. Each sheet is immersed fully in a sink or bath that is large enough to allow the paper to lie flat for a few minutes. Then I lift it out, let it drip/drain briefly and quickly lay it on a drawing board, securing all the edges with brown gummed paper. I try to stretch a number of sheets at a time so that there is always paper ready for use. For a very large sheet cut from a roll, such as that used for *Lilies and Jasmine* (reproduced on page 34), I leave the paper dry and stretch it very tightly across a canvas stretcher, using drawing pins placed closely together to hold it in place. I will actually use canvas pliers to pull the paper across the stretcher, though obviously not applying full strength!

The scale of my watercolours varies considerably, from the small studies which perhaps measure just 7.5 x 20.5cm (3 x 8in) to large works sometimes measuring 71 x 96.5cm (28 x 38in). As in choosing paper, the scale is largely determined by the subject

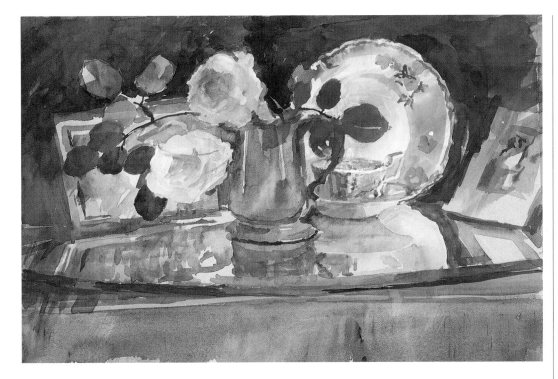

WINTER ROSES, WELSH DRESSER
*Watercolour and body colour,
25.5 x 37.5cm
(10 x 14³/4in)*

Whereas on a white paper the light areas can be 'reserved' or left unpainted, on a tinted paper they have to be painted in with Chinese white or white designers' gouache. In this painting the white areas were painted first, and where it was necessary to modify the white slightly or suggest any reflected colour I added very thin, weak and carefully applied watercolour washes.

matter and the techniques envisaged. In the very large watercolours, for example, I will use a big wash brush, 5cm (2in) or 6cm (2¹/2in), to lay in most of the composition. For a still life I seldom work larger than life size.

I use both tubes and pan or half-pan watercolours, and my basic palette is lemon yellow, cadmium yellow, raw umber, burnt sienna, sepia, cadmium red, permanent rose, Winsor blue, French ultramarine, Payne's grey, indigo, Hooker's green and Chinese white or permanent white designers' gouache. I may add other colours if a subject demands them, sometimes choosing one or two Schminke Aquarell colours if I need a denser consistency of paint, say in the earth colours. On the other hand, there are a few colours that I deliberately avoid because they tend to stain and kill everything else. Alizarin crimson and phthalo blue are among these and, for the same reason, viridian must be used with a great deal of respect. Whenever possible I work with mixes of just two colours, so as to keep the washes fresh and transparent.

Brushes are a very important element of watercolour painting, so I buy the best I can afford. Mostly I use Nos. 9, 7, 5, 3 and 1 Kolinsky sables in the da Vinci Maestro range, which I prefer because they are very responsive and hold their shape well – the tip returns to a perfect point even after a lot of use. What is notable about a good sable is its spring and flexibility, and it is these qualities that encourage lively yet controlled brushstrokes. For broad washes I choose a 2.5cm (1in) or 3.5cm (1¹/2in) flat wash brush, and sometimes I will use a No. 4 flat nylon square-shaped brush for lifting out areas. I am obsessive about the care of watercolour brushes, possibly because of their high cost. After use, I rinse them thoroughly in clean water, dry them with a rag or some kitchen paper, and store them in a cardboard box or, when painting on location, a fabric roll. However, when I am working with brushes I do not worry about their well-being and am quite happy to overload them with paint, drag them across the surface of the paper, or use them in whatever way is necessary to create a certain effect. A good quality brush will easily withstand this sort of treatment.

LILIES AND JASMINE
Watercolour,
114.5 x 71cm (45 x 28in)

For this large painting I experimented by stretching a sheet of Saunders Waterford paper across a canvas stretcher. I even used canvas pliers (although rather carefully!) to create the necessary surface tension before securing the paper around the edges with drawing pins.

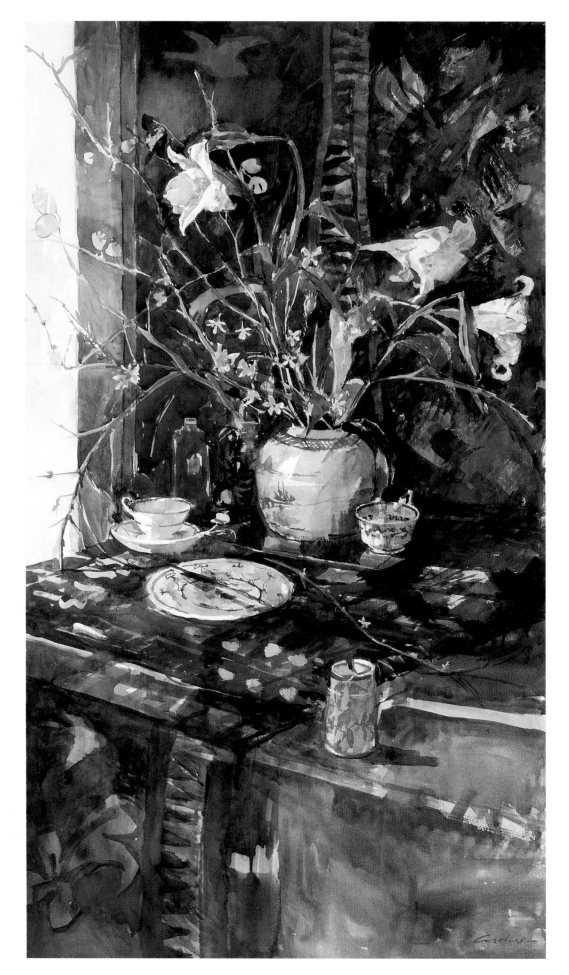

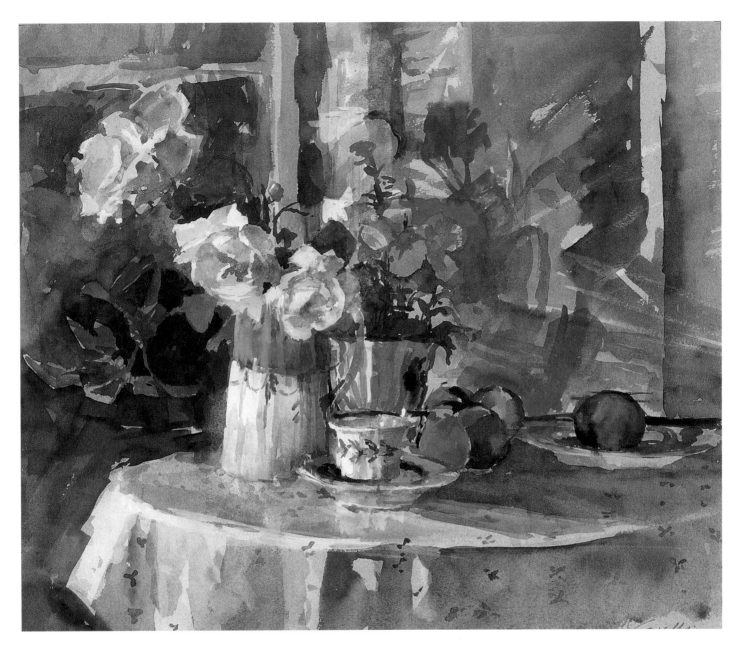

ROSES ON THE ROUND TABLE
Watercolour and body colour,
33 x 38cm (13 x 15in)

Here, building from light to dark, I mainly used a wet-in-wet technique, floating each wash into the previous one.

I rarely use masking fluid, and never mix pigment with gum arabic or any of the other watercolour media that are now available. My experience of masking fluid is that it leaves lines and areas that are far too distinctly defined. When using white paper I will reserve whites in the traditional way or lift out colour, while on tinted paper I can obtain whites with Chinese white or white gouache.

Except for the sketchbook studies, I prefer to stand and paint, so that I can look down on the painting and work at arm's length. In the studio I use the radial easel, which adjusts to an almost horizontal position, or sometimes the oil-box easel, or I simply prop the board up on a table with a book or cigar box. Outside, if I am painting on stretched paper taped on a board, I normally use the oil-box easel, swapping the oil paints, oil palette and so on for my watercolour equipment. If required, the lid tilts at 45 degrees, or I work flat. For most outdoor work I use my Italian watercolour box, which holds 12 pan colours in a removable tray and has six shallow mixing wells. I also have a Cotman Field Box, which includes a

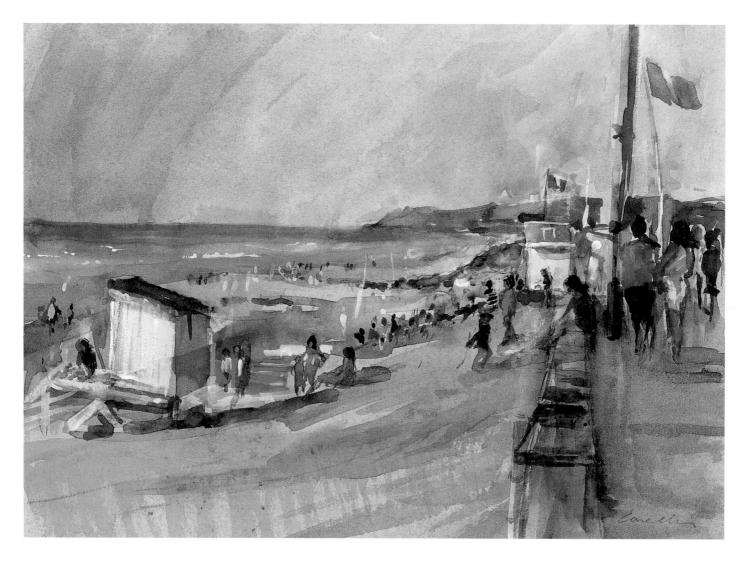

BEACH HUT, EARLY AFTERNOON,
NORMANDY
*Watercolour and body colour,
18 x 25.5cm (7 x 10in)*

*I find watercolour ideal for this
sort of response, where I can
quickly capture the general
composition and atmosphere
of the scene.*

water bottle and a separate water holder that fits neatly over the end of the box. In all, this measures only about 5.5 x 12.5cm ($2^{1}/_{2}$ x 5in), making it the perfect size to slip into my coat pocket with a small sketchbook. Alternatively, if I have a large stable area to work at, such as in my studio or when I have the car, I use tubes of paint and a box palette that opens into two sections, with deep wells for mixing washes and a large flat mixing area.

I am fortunate to have three studios to work in. The one at my home is small and also has to serve as an office, but nevertheless I can paint in both oils and watercolour here if I wish, although there is limited room to stand back and see what I have done. A short distance away I have my main studio, which is fully equipped for the different media I use, including etching. Incidentally, this faces west, which I quite like as I think a north light can be very cold. My studio in Wales is where I do most of the preliminary landscape work.

I painted my first watercolours when I was on a visit to Spain and needed a convenient painting medium to use on my travels. Before then I had not seriously tried the medium because I believed it to be difficult and technically demanding. I was under the impression that watercolour must involve lots of careful washes and clever brushstrokes, and that once in place these could not be changed. So it was a great relief when I found that, after all, here was a medium which allowed a good deal of freedom and individuality. In fact, I

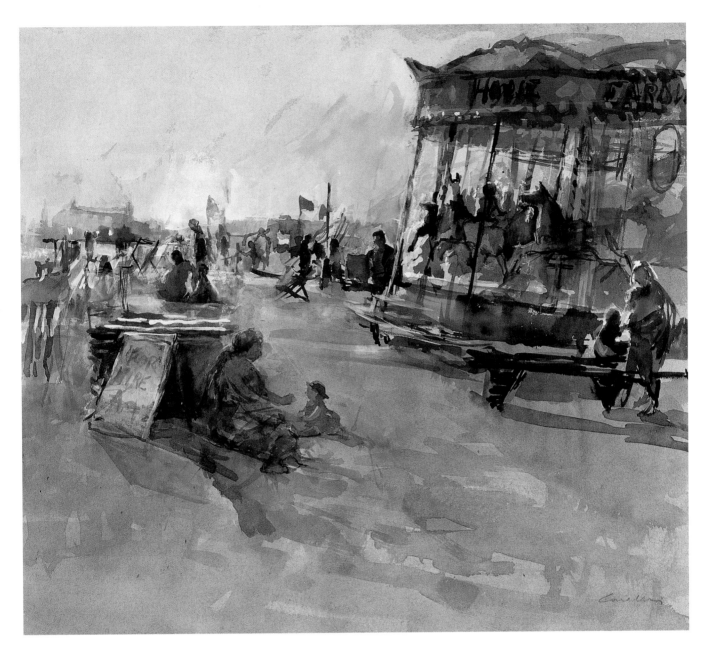

LATE AFTERNOON,
CAROUSEL AT BRIGHTON
*Watercolour and body colour,
33 x 38cm (13 x 15in)*

soon learned that too much reliance on a meticulous finish could be a trap and that a better approach, as I once heard someone say, is to settle for 'an apparent awkwardness rather than a dazzling technique'.

When working on white paper I sometimes begin with a weak pencil outline, though more often I go straight in with paint, using a pale combination of Payne's grey and raw sienna. This produces a mid-grey/green which, if applied very lightly, makes an ideal base colour. At this point I begin laying in washes, but these have a considered random quality rather than being applied too meticulously. From then on it is a matter of developing the painting wash over wash, working mainly wet-into-wet, defining some areas and perhaps lifting out the colour in others. I lift the colour with either a rag or a sponge, or in some cases with a dry flat brush. I try not to think about technique, because if I am concentrating too much on technique and constantly questioning whether or not something will work, my attention is drawn away from the subject.

This began as a location study, but back in the studio I decided to develop it further, and so it became a painting in its own right.

37

FISHING FROM THE ROCK,
PEMBROKESHIRE
Watercolour,
14 x 25.5cm (5¹/2 x 10in)

A quick sketch working with a very limited palette.

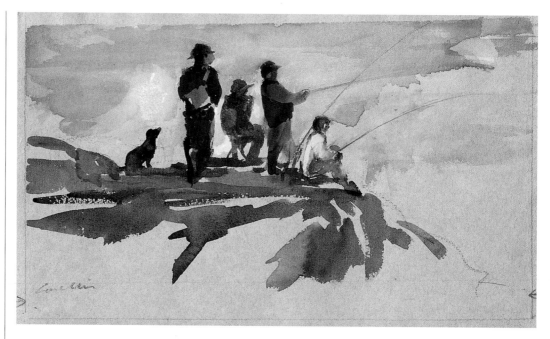

BEACH CHAIRS, PEMBROKESHIRE
Watercolour,
9 x 28cm (3¹/2 x 11in)

Fast sketches like this demand one's full powers of observation and concentration.

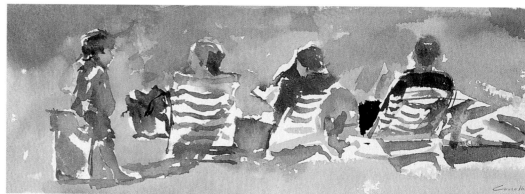

With coloured papers I adopt quite a different approach – looser and more experimental, and far more in sympathy with my natural way of working. I lay thin washes of white over the paper, letting the base colour show through here and there where it will help my interpretation of the subject. I use Chinese white watercolour for a very delicate tone, or designers' white gouache for a more opaque wash. Once the white paint is dry I work over it, wet-into-wet, with different colour washes. However, I never actually mix the white pigment with a colour as I find this produces an unpleasant creamy consistency. Sometimes at the end of a painting I will define areas with touches of fairly dry paint but on the whole I prefer to keep the work as fluid as possible. It is very easy to overwork a watercolour, but requires great discipline to leave well alone!

When painting outside I might decide to make a large, finished watercolour or concentrate on a series of small studies. The paintings reproduced on pages 30 and 31 are interesting examples of large works started on site. For *Shadows on the Thames, Southwark* I had access to a roof terrace and so could choose my viewpoint and paint without undue disturbance. I spent a day laying in the initial washes and beginning to develop the painting, finishing it in the studio later. In this situation I was able to use my larger palette and work with tubes of colour – my preferred method. I chose a green-tinted 300gsm/140lb mould-made paper, which I felt would help me bring out certain important qualities in

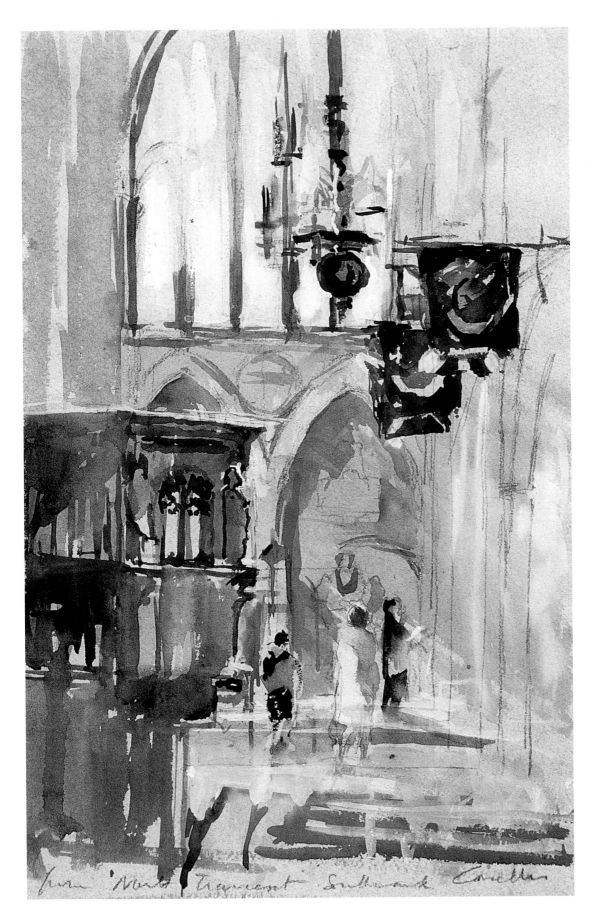

FROM THE NORTH
TRANSEPT, SOUTHWARK
Watercolour,
28 x 18cm (11 x 7in)

**In this study, which I
later used for an oil
painting, I was mainly
interested in the relative
scale of things.**

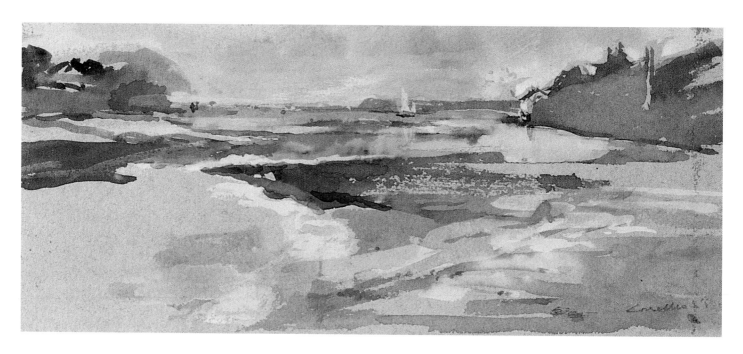

NEVERN ESTUARY II
*Watercolour and body colour,
9 x 19cm (3¹/2 x 7¹/2in)*

*I used Turner grey paper for
this very quick study, which I
painted from the car.*

the subject. I used one of several sheets I had previously bought in Italy to try out. This paper has a smooth finish and accepts washes well.

Out on location my main concern is to get as much information as possible down on the paper before there is a significant change in the light. More often than not it is the quality of light and the mood and atmosphere this creates that is the real inspiration for a painting, so it is important to remain faithful to a particular type of light if the work is to be successful. In this respect, I continually have to remind myself to concentrate on what I actually want to say about the subject – in changeable lighting conditions, it is easy to go off at a tangent when the subject is seen with, for example, deeper shadows or warmer colours. In time, as the sun goes round, shadows and reflections change dramatically, and then I know I must stop.

For the small studies, there is the option of either working in transparent watercolour on white paper or using white gouache on a tinted paper. The choice depends on how I see the subject, and it is almost a spur-of-the-moment decision. I choose a particular location and set out with the intention of doing as many small studies as I can. On such trips I prefer to travel light, so equipment and materials are kept to a minimum. As well as a box of pan paints, I take a small sketchbook for pencil notes and studies and either an A5 Bockingford 300gsm /140lb watercolour pad or a few sheets of watercolour paper taped onto two small panels of display board (Foam Centre Board), which is extremely lightweight and consequently easy to carry around. These two panels are taped together along one edge with masking tape to make an improvised folding 'sketchbook'. Small sheets of Turner grey and white watercolour papers are taped to both sides of the panels, giving a selection of sizes and surfaces to work on.

Back in the studio, I will have another look at the paintings to see if any further work is necessary. Sometimes I am happy to leave everything just as it is, but on other occasions I may need to make a few adjustments, perhaps strengthening some areas or sponging out others. In fact, this is what I did with the paintings shown on pages 30 and 31 to help emphasize the lights and darks. In both paintings I was intrigued by the shadows on the surface of the water.

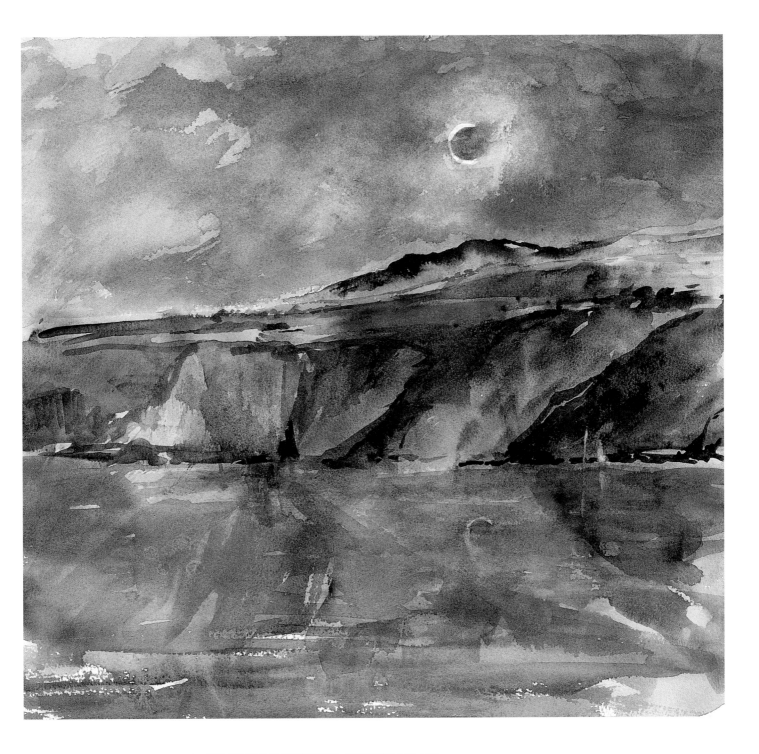

THE ECLIPSE FROM THE SEA, CARDIGAN BAY, 1999
Watercolour, 35.5 x 40.5cm (14 x 16in)

*This was one of the rare occasions when I have used masking fluid:
I used just a little around the edge of the sun to keep it white and
sharply defined. The sky effect was mainly created by dabbing
paint on with a sponge.*

ALEX, PORTRAIT STUDY
*Watercolour and body colour,
35.5 x 28.5cm (14 x 11¼in)*

*To capture the delicacy of the
sitter's face, half in shadow, I
had to work in a single
continuous session.*

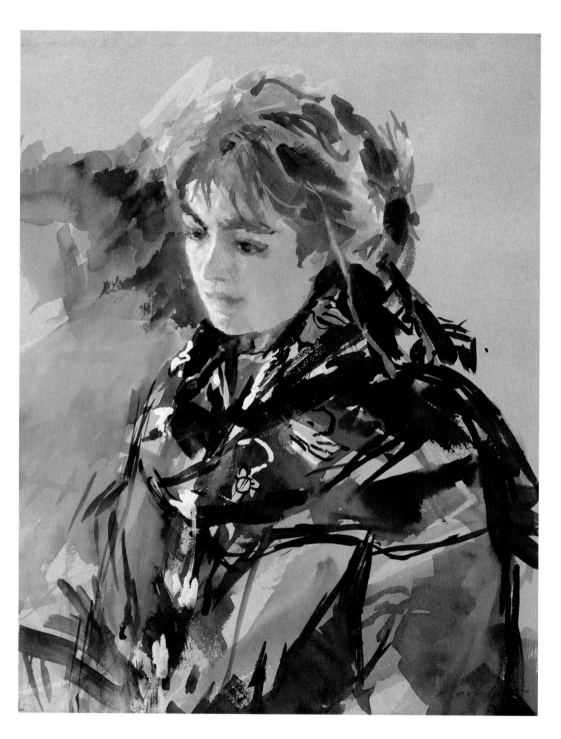

Opposite
JANE, PORTRAIT STUDY
Watercolour and body colour, 34.5 x 27cm (13½ x 10½in)

*I chose a soft green hand-made paper for this portrait, partly
because the texture and colour seemed to complement Jane's bright
clothing and hair and partly because I thought it would withstand*

*a fairly vigorous treatment. As in the portrait of Alex shown
above, I started with broad washes of white gouache – some quite
thick to obscure the paper colour and others much thinner in order
to let the green gleam through, especially on the face and neck.
Although I applied a lot of wet-in-wet washes the paint was
mostly handled rather like oil paint, so giving an interesting
contrast between vigorous and quite delicate passages.*

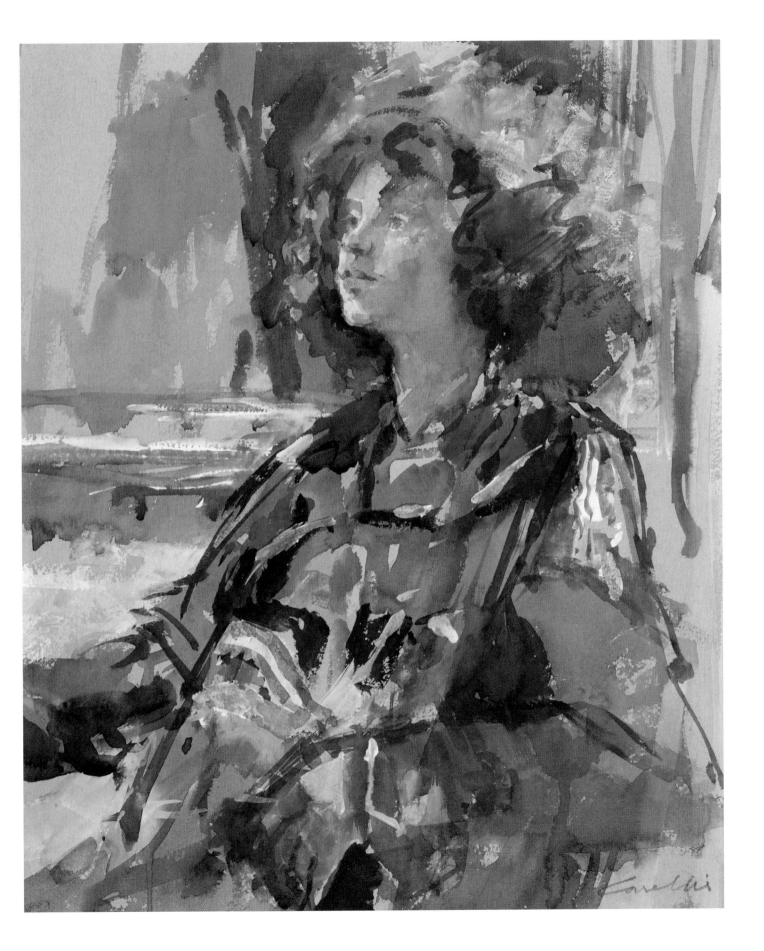

DEVELOPING IDEAS

First-hand observation and experience of the subject is very important to me. In my landscapes, for example, whenever possible I will do at least some of the painting on site, while all my interiors, still lifes and portraits are worked directly from the actual subjects. Sometimes I know exactly what I want to say in the painting and therefore I can get straight on with it, but more often, especially with the larger, complex works, I like to begin with some studies. These help me find a way into the subject and to explore different possibilities. They also provide useful back-up material and a source of confidence while the painting is taking shape. I like to establish a positive aim and intention for each painting before I begin and in this respect I usually find that some preliminary work is essential. Drawings, watercolours and oil studies help me understand the subject and reach a decision as to how I want to interpret it.

This is an approach I have used since art school. Perhaps some artists would find it an inhibiting way to work, but I do not. In fact it can be quite the opposite, generating the scope to take the idea much further in the final painting and in so doing encouraging freshness and originality, qualities that are essential in any work. Usually, no matter how many studies I make, it is the painting on the canvas that will take over. If I find I am referring too much to the studies, I will put them away and if necessary take the canvas back to the site to help reassess my intentions. In other words, I believe that studio work has to be a combination of considered composition which has evolved from development sketches, and imagination. But in the end it is the quality of what is on the canvas that counts, however this is achieved.

I may do a whole sequence of pencil, watercolour and oil studies in order to explore a subject, but I do not regard these as necessarily being a step-by-step progression towards a single idea. Most likely each study will suggest some different quality or aspect of the subject and in this way will contribute to a final painting, or indeed several different paintings. This said, the distinction between a study and a finished work is not always apparent. When I begin a study I am never quite sure whether it will simply serve as a reference for a more resolved painting in watercolour or oils, or become a finished work in its own right.

Tackling a breadth of ideas keeps my work fresh and moving forward. I find that my motivation comes from the challenge of variety rather than specializing in one type of subject matter. Each subject offers something different and inevitably brings new problems to solve, which is stimulating and enjoyable. My subjects range from landscapes, interiors and still lifes to portraits and nude studies. I am never at a loss for ideas, in fact there is usually a list of things I would like to paint. Sometimes I deliberately go out looking for subjects, and here the opportunity to travel has been important in offering me a wealth of exciting places in which to paint. Also, being a very self-critical painter, what I

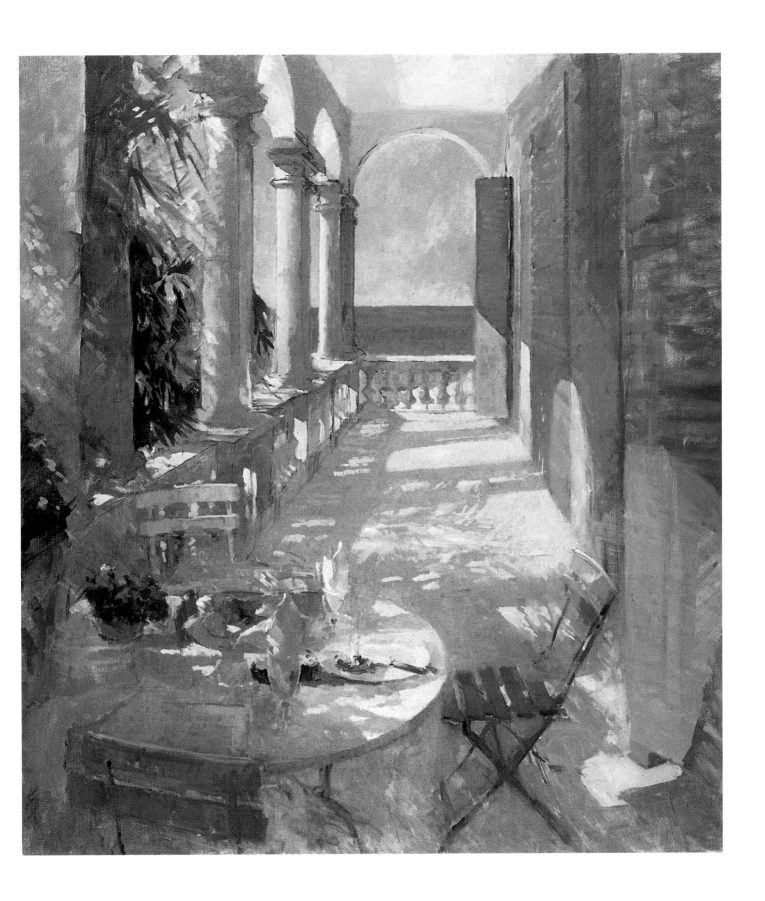

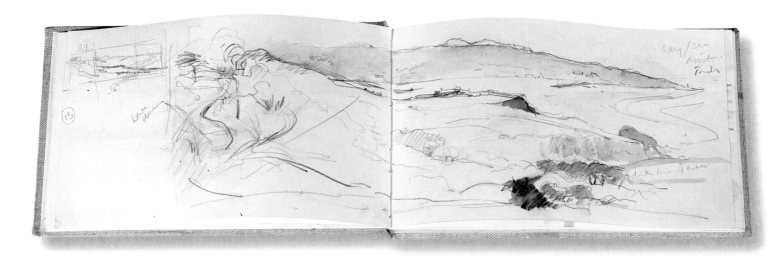

FISHGUARD: SKETCHBOOK STUDY
*Pencil and watercolour wash,
14.5 x 47cm (5³/4 x 18¹/2in)*

see as a weakness in a painting will often inspire me to try another idea in which I can somehow build from a previous problem, solve it and use it to advantage as it were. But generally a change of subject matter seems to evolve quite naturally. For example, I may be painting an interior and will then see one small part of it which I think will make an interesting still life.

Without any doubt, the quality that always attracts me to a subject is the light. Different conditions of light will influence a subject's appeal, and while a landscape, for example, may look dull and uninspiring at one moment, a change of light can fill it with colour and interest. Many of my subjects are quite ordinary but there is always a particular quality of light within them which, to me, has a special attraction.

While light is an inspiration, time can be a limiting factor, especially when painting outside. However, a positive aspect of working within time limits is that it does help to concentrate one's attention and ensure a focus on a particular aim or type of work. *Towards the Sea*, on page 45, illustrates this point. I had been painting in Italy and, on the way back, decided to stay at Menton for a week, where I visited the Villa Maria Serena. There was certainly no need to search for subjects here, as everywhere I looked there seemed to be something interesting to paint. It was a question of what not to paint, rather than trying everything. So, because of the time limits, I decided to concentrate on some large works of the Villa Maria Serena and, during breaks, on smaller studies of the town and beach.

Some ideas come from commissions. I quite like the fact that these channel my interest in a certain direction, but I never accept commissions that are too specific or defined – there must always be room to manoeuvre! Commissions are usually major works and therefore I will do a lot of preparatory studies to investigate and develop the general theme.

When I was commissioned to paint the Pembrokeshire coast and Cardigan Bay, for example, I started with various sketchbook studies of Fishguard, concentrating first on the harbour from the Preseli Hills and then the Lower Town Harbour. These were then followed by several serious exploratory paintings, from which I decided that I could not satisfactorily convey what I wanted to say about the subject on a single canvas. The fact that this was an important work, and therefore I ought to try something courageous, combined with my observation that the landscape divided itself naturally into three sections, led me to the conclusion that I should do a triptych. I started in the summer and

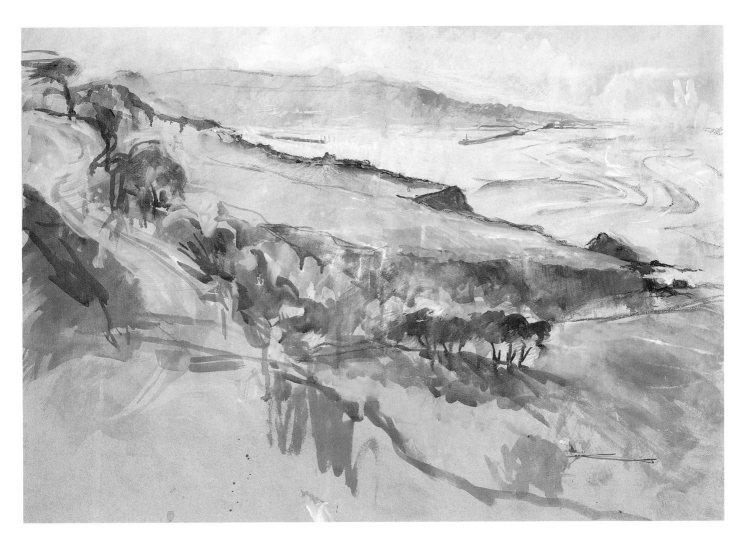

FISHGUARD HARBOUR
*Watercolour and body colour,
53 x 74cm (21 x 29in)*

*This was quite thinly painted,
using mainly wet–in–wet
washes.*

was not particularly happy with the all-over golden light. However, as often happens on this coast, the late autumn light was perfect and by that time the fields had turned blue-green and there was a slight haze. So, this painting developed over a period of five or six months, with most of the work done on location.

Because of the need to catch the right light, and other factors, I never work continuously on one painting but perhaps spend time on two or three in the course of a day. The problem of light is exacerbated when the subject is a seasonal one, and sometimes I have to wait a year before I can go back and continue such a work! During a long project I may well see other ideas that I would like to tackle. Usually I have to be patient and come back to these later, but sometimes starting another painting can actually benefit or complement work in progress. It is always better to start a new painting than to try to incorporate a different approach and other aspects and ideas into a painting half completed.

While I was painting the triptych I worked on the Lower Town paintings shown on pages 52 and 53. Both of these were exploratory studies, with the oil painting completed on site and the watercolour, in which I wanted a 'lighter' approach, painted in the studio. For this subject I was limited by the state of the tide and the light. Success depended on capturing the particular afternoon light at low tide – were I to miss the right moment, it would mean waiting another two weeks. Also, the boats are up on the quayside for only a few months each year. Fishguard is an endless source of subject matter and I have gone

FROM THE PRESELI HILLS,
SUMMER
Oil study,
40.5 x 51cm (16 x 20in)

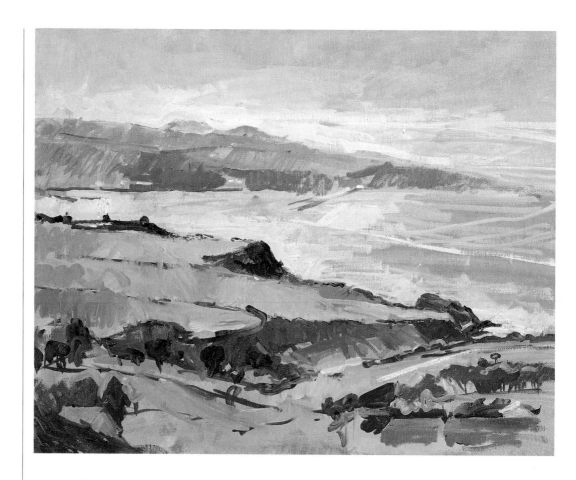

FROM THE PRESELI HILLS,
AUTUMN
Oil study,
15 x 23cm (6 x 9in)

This and the study above were both used as information for the oil painting shown on the opposite page.

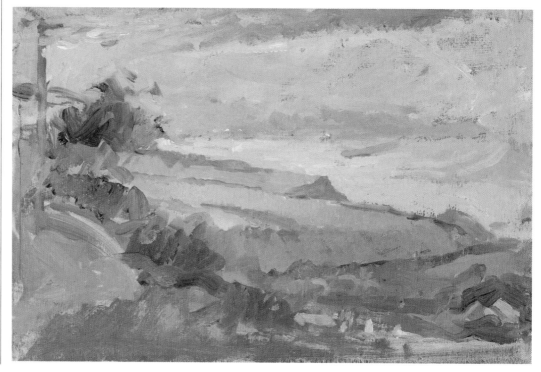

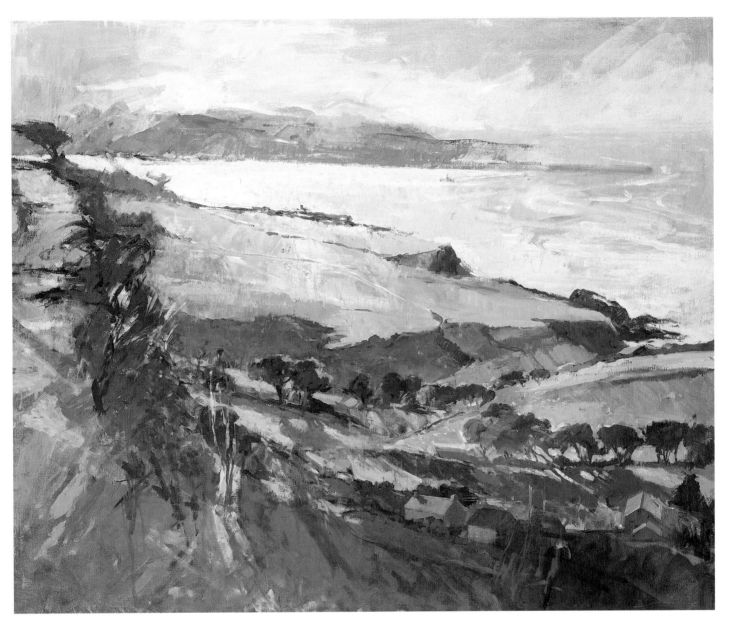

FROM THE PRESELI HILLS
Oil on canvas, 76.5 x 91.5cm (30 x 36in)

Working in the studio and on location, I began this canvas with the intention of making it the final, resolved painting. But I gradually realized that the composition was not going to work and, as the landscape divided itself naturally into three sections, decided that the best solution would be a triptych.

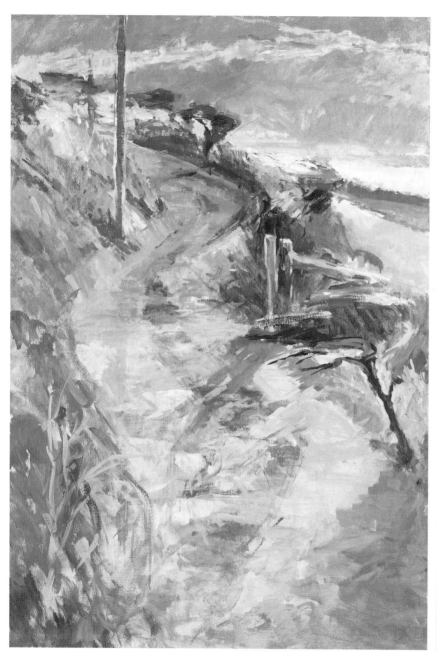

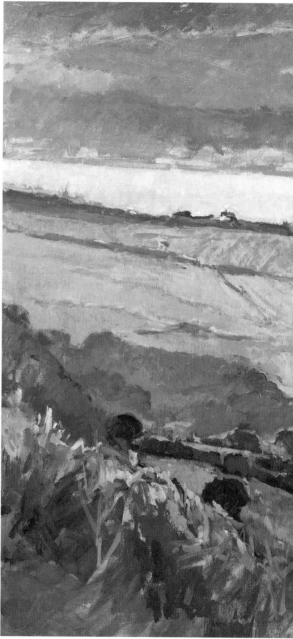

on to paint a number of works, both in oils and in watercolour. The change in tide, when it exposes rivulets and rocks, is always exciting, as is a higher tide, when the houses, smoke, boats and so on are reflected in the water.

As I have said, travel has always been important in my work and I deliberately choose new places to visit in the hope that these will inspire fresh ideas. The Brighton paintings were the result of this kind of approach. I needed to do some work for an exhibition and wanted to paint a colourful seaside town, so I rented a flat for a month in Brighton, which was somewhere I had not visited before. New places, I find, provide a much greater stimulus than returning to familiar territory.

During the first week I spent every day making sketchbook notes and small oil studies which would help me decide exactly what to develop as considered paintings later. These studies were just visual notetaking, to be used, or not, in the final paintings. Their

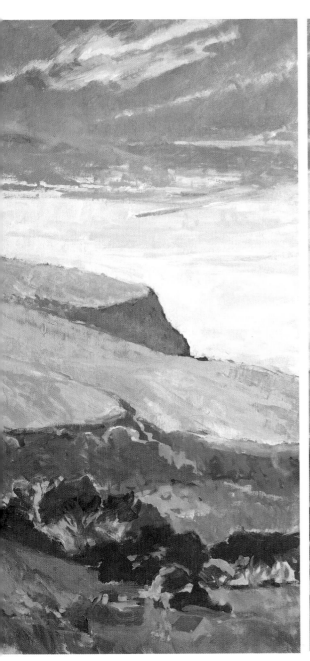
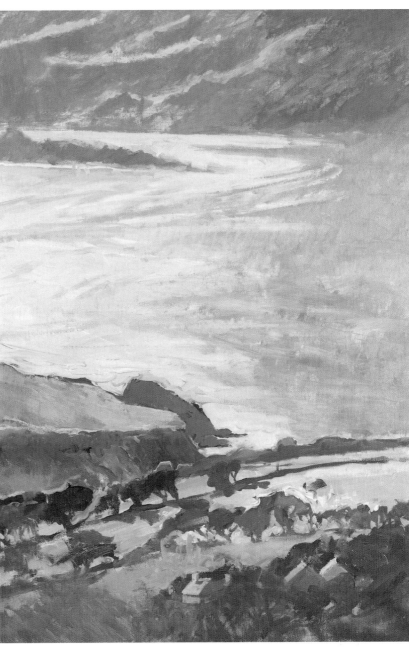

aim was to record what the light did at certain times of the day, brief information about people and buildings in colourful daylight or *contra jour*, and so on. They needed to convey mood, light and general structure, using quick outlines rather than a great deal of detail – providing any form of reference that would help me recall the scene and paint it with feeling and confidence. *Deckchair Girl, Brighton Beach*, reproduced on page 55, was painted from these various studies, while the *Beneath the Pier* paintings on page 54 were painted on the spot.

For most interiors, still lifes and other studio-based subjects I will follow a similar working method, first getting to know the subject through sketchbook studies and then starting on the actual painting. The brief sketches or 'maps' also help me decide on the composition, for there is nothing worse than getting halfway through a painting only to find that you should have moved everything several centimetres to the left! In the same

OCTOBER LIGHT FROM THE
PRESELI HILLS
*Oil on canvas, 91.5 x 214cm
(36 x 84in)*

Many sketches and oil studies helped towards painting the triptych, and I also took all three panels to and fro so that I could work on them in front of the actual subject as well as in the studio.

THE LOWER HARBOUR,
FISHGUARD
*Oil study, canvas laid on
board,
18 x 29cm (7 x 11¹/₂in)*

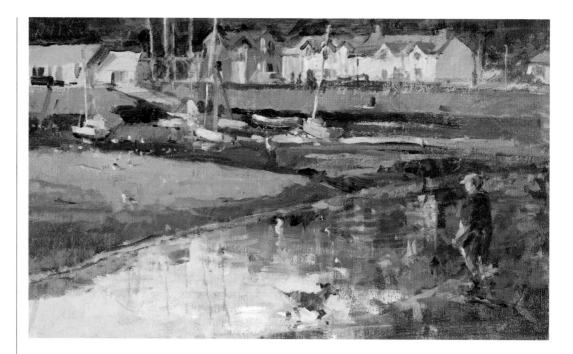

BOATS LAID UP FOR THE WINTER
*Oil study, canvas laid on
board,
25.5 x 35.5cm (10 x 14in)*

*From this exploratory study
I decided that a more resolved
version of the subject would
work better with the lighter
touch of watercolour rather
than as a large oil painting.
I felt that the massive harbour
wall would look too dominant
in an oil painting but could be
interpreted in a less intrusive
way in watercolour, as I hope
the painting on the opposite
page shows.*

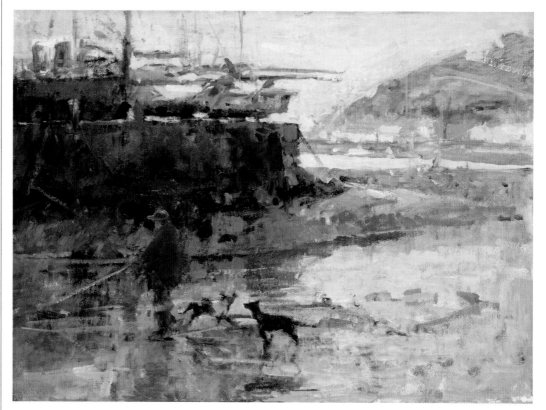

context, I will rearrange objects in a still life or interior – perhaps moving a chair, or
opening a window – in order to find the most interesting arrangement. However, with
portraits my approach is slightly different, as I usually begin with one or two intense tonal
drawings in pencil or charcoal. These help me to discover as much information as I can
about the sitter before starting work on the canvas.

The *Welsh Dresser and Lamplight* studies on pages 56 and 57 are typical of the way I

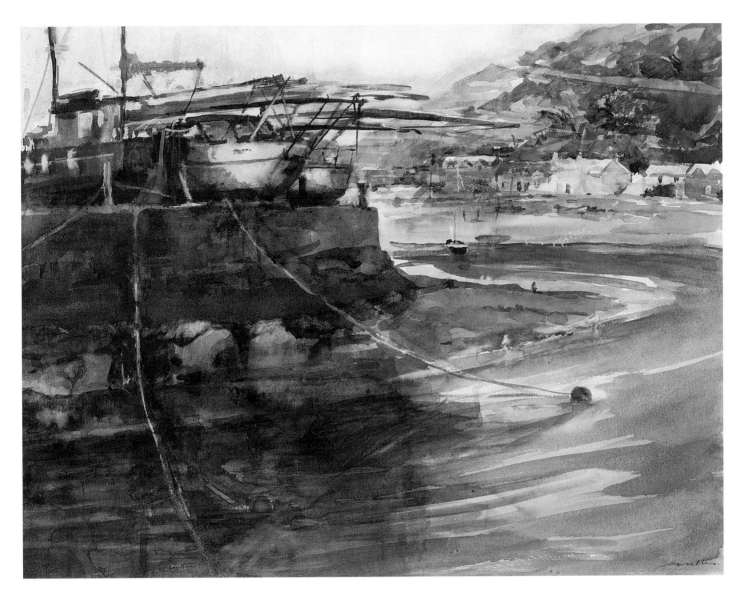

BOATS LAID UP FOR THE WINTER,
LOWER FISHGUARD
Watercolour,
38 x 48cm (15 x 19in)

develop ideas with still-life subjects. Here it was the lamplight that first caught my eye – how the peculiar quality of light from the lamp influenced the whole subject. In the first study I have concentrated on this, accepting the arrangement of objects just as it was. However, in the second and subsequent studies I began to explore different viewpoints and started to shift objects slightly in order to create greater contrasts and more impact in the composition.

As here, I usually begin with a watercolour study. I find watercolour a more relaxing, less inhibiting way to start because if things go wrong I can simply screw up the paper and throw it away. Another advantage of working in watercolour is that it allows you lots of freedom to simplify shapes. This Welsh dresser is in my cottage in Pembrokeshire. It is a subject that I often return to. What I especially like about it is the rich dark wood and the way this can provide all sorts of contrasts when the lamplight reflects on it. I have always enjoyed painting still lifes, although initially I would use them purely as a means of getting back to basics when I was experiencing problems in other paintings. However, I have become more and more interested in this genre and it now forms an important part of my work.

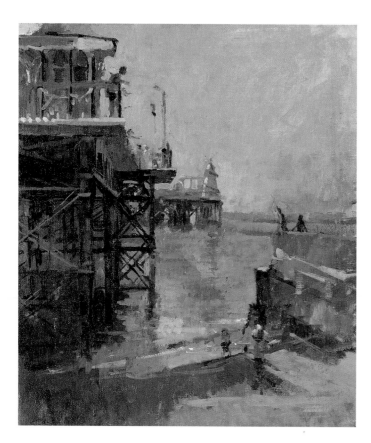

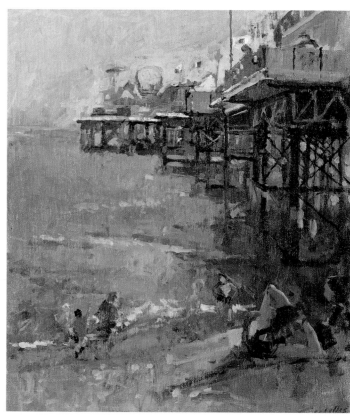

Both this and the painting above right began as location studies, but I became so involved with the subject and the general atmosphere and activity that I pursued each study to a conclusion.

The preparation for a large project might involve a whole body of preliminary work that includes information in a sketchbook, drawings and photographs, and watercolour and oil studies. For me, a sketchbook is not a place for detailed drawings, but somewhere to jot down helpful clues about the subject. My sketchbooks contain a mixture of very simple outline sketches, line and tone sketches, quick watercolour studies and other drawings in colour, and written notes. Mostly I work in pencil, though occasionally in pen and wash or with water-soluble pencils.

Sometimes I will make quite resolved drawings, focusing on mass and line and working in pencil, charcoal, or very occasionally pastel or conté. I usually regard these as works in their own right rather than studies. The added value of making such drawings is that they help concentrate the mind, sharpen one's powers of observation, and create a better understanding of tonal values. For this reason, if I am struggling with the shape or form of something in a painting I will stop and make a drawing to clarify what is there. Then, when I return to the painting, I am able to continue with more confidence.

I think it is essential to plan painting trips quite carefully, in respect of both the location and what equipment to take. Whenever possible, I choose a sheltered site to work from, and I try to ensure that I am not going to be too cold or uncomfortable. Battling against the elements and extreme discomfort is guaranteed to result in hasty and poor work, I find! As well as the necessary painting equipment, thermos, gloves, hat and so on, I always take my camera.

Photographs can be a useful aid, particularly as a reference for moving figures and other details. Recently I have been experimenting with a digital camera and this has proved very useful in the way that images can be manipulated on a computer screen. For example, I can focus on areas and enlarge them and try out various alternative composi-

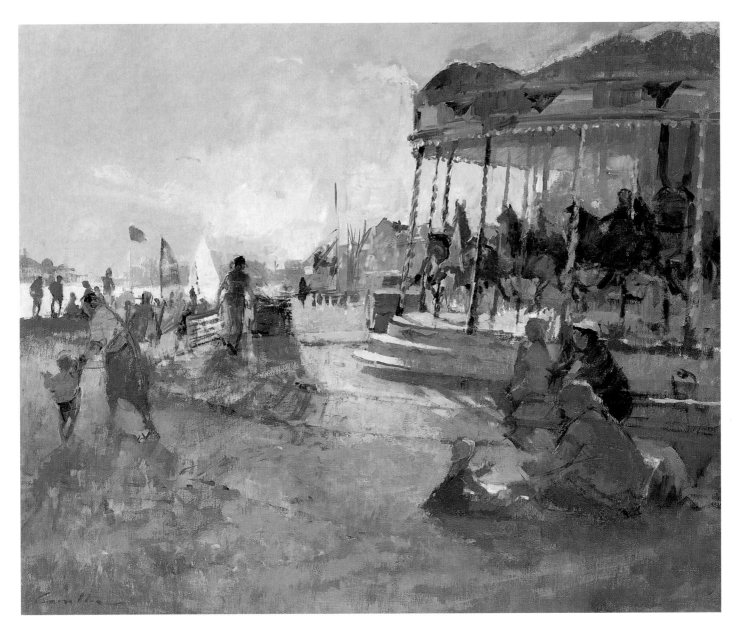

tions, which is something I have found particularly interesting and helpful when planning still lifes. However, I am not yet totally convinced by this method, thinking that perhaps it is just the fun of a new toy! In any case I would never advocate painting exclusively from photographs. I once tried this, but it was a complete failure and simply proved that there is no substitute for working on site. A rapport with the subject can only develop from actually being there and experiencing it.

In practice, the studies and other reference material jog my visual memory as well as providing a wealth of information and possible ideas. So, for example, when I am developing a landscape idea in the studio I try to visualize the scene in my imagination and recall what I sensed and felt about it. My paintings are essentially about a truth, a particular subject, and I hope to include in them those qualities of light, colour and paint handling that so interest me. But I am not after a perfect, unemotional truth – rather one that reflects my particular thoughts and feelings about the subject.

DECKCHAIR GIRL,
BRIGHTON BEACH
*Oil on canvas,
56 x 66cm (22 x 26in)*

As here, sometimes the studies, combined with my recent experience of the subject, can be a sufficient source of reference and enable me to do all the painting in the studio.

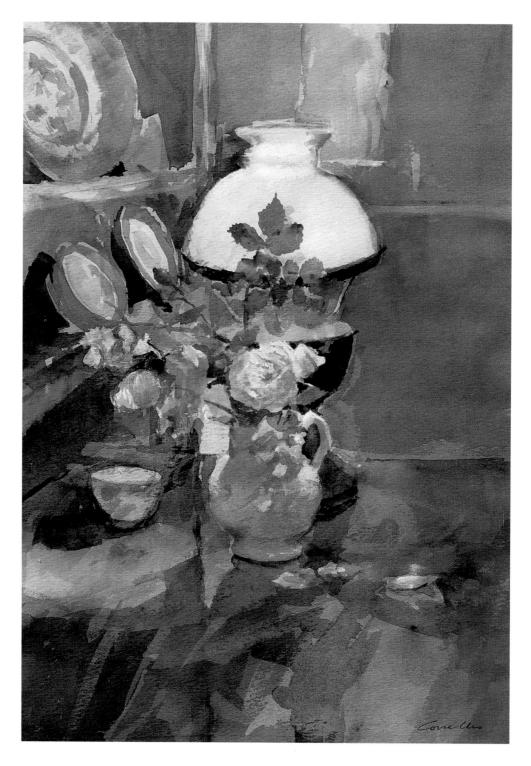

Studies are helpful in exploring not only different viewpoints but also different qualities within the subject, and this is why I often like to try both an oil and a watercolour study.

I usually begin with a watercolour study as I find it a less inhibiting way to start, and it also allows plenty of freedom to simplify shapes.

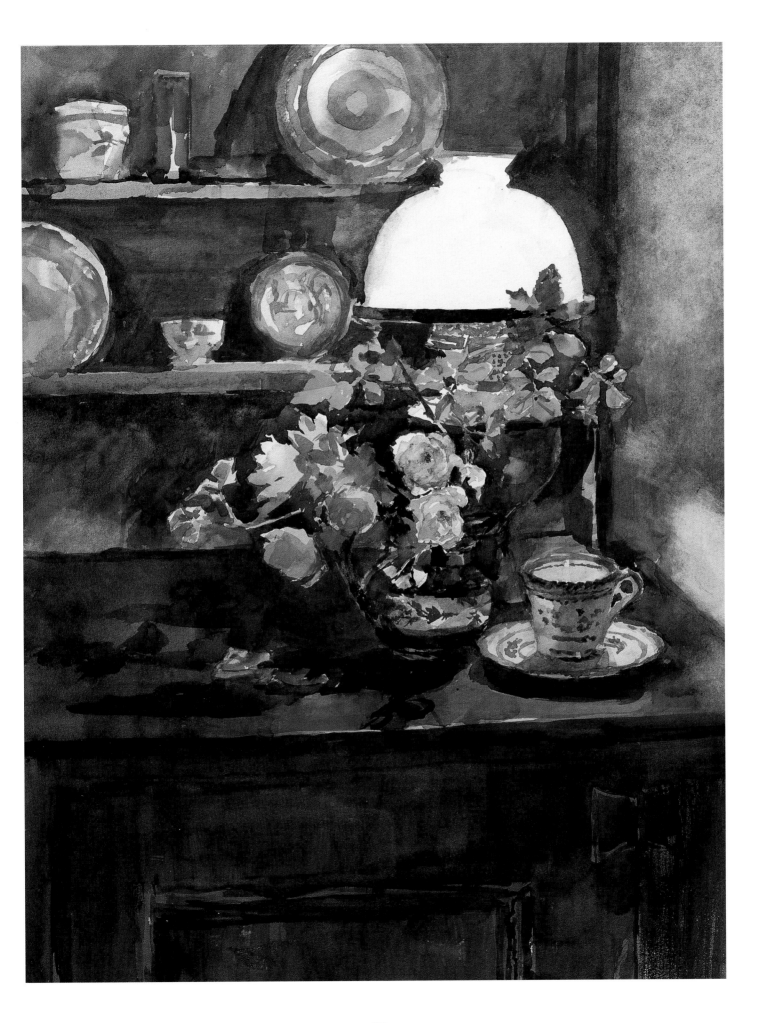

COMPOSITION

Whatever the appeal of a subject, to succeed as a painting it must somehow involve an interpretation that is founded on a dynamic and visually pleasing structure or framework. There are many subjects, I find, where this sense of order and design is inherent and I can simply exaggerate or play down aspects of it to produce the sort of contrasts and arrangement I want. In *Southwark*, for example, reproduced opposite, the relationship of buildings and river created an instant composition. On the other hand, there are occasions when my initial concern is with the subject matter, and the composition evolves later, or, as is the case with most still lifes, the arrangement of shapes is totally contrived. But in every painting, whatever the circumstances, composition is all-important. It is something I am always aware of, from the first sketches through to the final stages of a painting.

As well as providing the 'scaffolding' to help build and develop a painting, the composition plays a vital part in creating interest and impact. Indeed, it is generally true that no matter how well an idea is expressed in terms of colour and technical skills, if the underlying composition is weak then the painting will not be a success. Here I believe one needs a combination of instinct and experience to decide how to organize the composition, such that it presents the subject matter in a way that can be clearly understood by others yet is exciting and original. And while some compositions are planned, or at least manipulated, others are purely intuitive.

Although I paint from life I do not feel obliged to record faithfully every detail and scrap of information in front of me. Painting has to involve interpretation, and this inevitably has an effect on composition. I may, for example, accentuate a diagonal, intensify a patch of light, or extend a shadow if this kind of emphasis is required to give the composition more impact. However, in resolving a composition it is usually a matter of simplification, of deciding what to leave out, rather than of adding anything.

I learned the fundamentals of composition at art school. It was here that I was introduced to devices such as the Golden Section, that intriguing mathematical proportion accepted by the great artists and scholars of the Renaissance as having special artistic significance and aesthetic value. The exact proportion is 0.618 to 1, or roughly 8 to 13, and applied to a painting it means that approximately two-fifths of the way across the picture is the best place to include a tree, a figure, or some other significant feature. This creates an unsymmetrical composition, with the proportion of the smaller area to the larger the same as that of the larger area to the whole.

During my student days I also did numerous copies of paintings by Piero della Francesca, Uccello and so on at the National Gallery and the Courtauld Galleries. It was interesting to see how these great painters had created visually very satisfying and harmonious pictures that were essentially developed from a carefully devised arrangement of

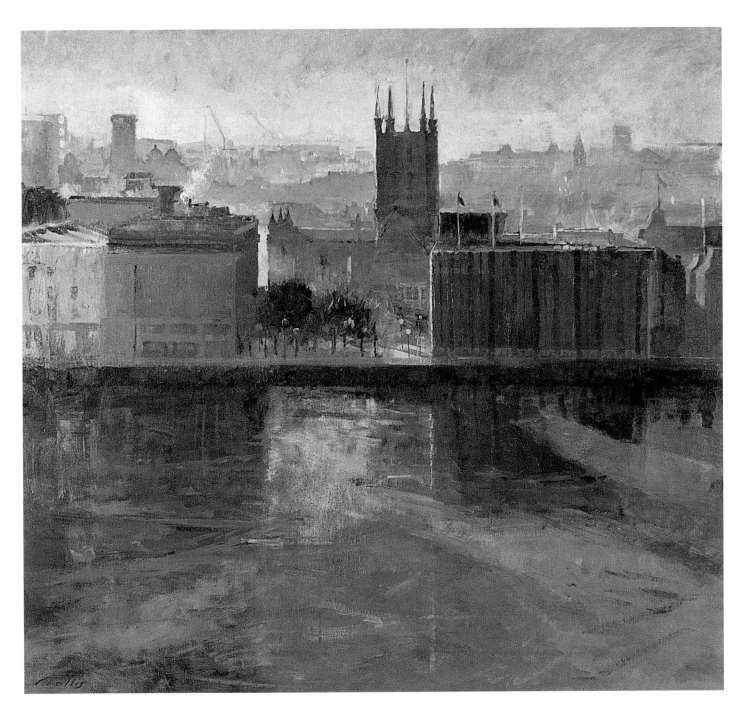

SOUTHWARK
Oil on canvas, 96.5 x 102cm (38 x 40in)

I like painting cityscapes because I often find that the formality and massive shapes of the buildings fall naturally into an almost obvious classic composition. Also, I enjoy the challenge of trying to bring out the drama of the subject, which after all could otherwise be just an architectural study of some buildings.

 In this painting the bold, vertical shape of the tower is opposed by a very strong horizontal line at ground level, with various other diagonals and verticals used to help link the two parts together.

JET TRAILS OVER THE NEVERN
ESTUARY
*Oil study, canvas laid on
board,
32 x 42cm (12¹/2 x 16¹/2in)*

*This small painting and the
one below were made solely as
exploratory studies for an
evening 'estuary' subject. I
wanted to discover the best
natural composition with this
land/seascape. In this first
study I was intrigued by the
curve of the river with its
spiral effect leading to the sea.
At this point the jet trails had
caught my eye but were not a
significant part of the
composition. I probably put
them in instinctively to
balance the boat on the right.*

JET TRAILS OVER THE NEVERN
ESTUARY
*Oil study, canvas laid on
board,
46 x 35cm (18 x 13³/4in)*

*I made this study a few metres
further on, and here I liked the
more obvious way the river
could be used to lead the eye into
the centre of the composition
where there were interesting
horizontal bands of colour. I
also noticed that the shape of
the far headland balanced the
shape of the river by echoing its
curve, and that the positive/
negative, light/dark contrasts
of these shapes could similarly
benefit the composition.*

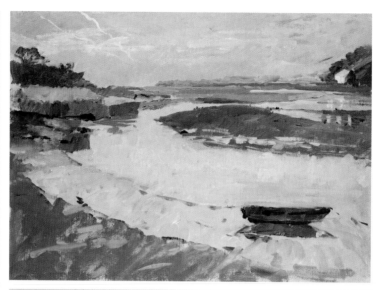

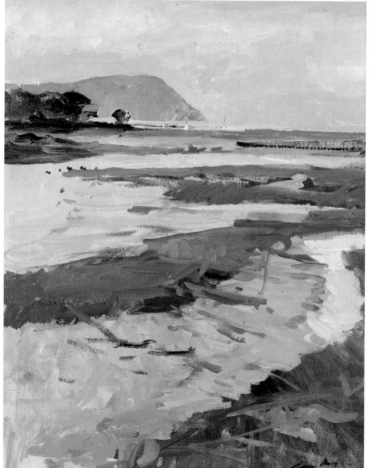

geometrical shapes. The triangular composition in the head and shoulders Madonna and Child portraits painted by many Renaissance artists is another example of this. In contrast there is no obvious planning or use of conventional compositional devices in the work of artists such as Van Gogh and Matisse. They used a much less obviously structured and more spontaneous and intuitive kind of composition.

My study of composition was a revelation and I have always valued the knowledge

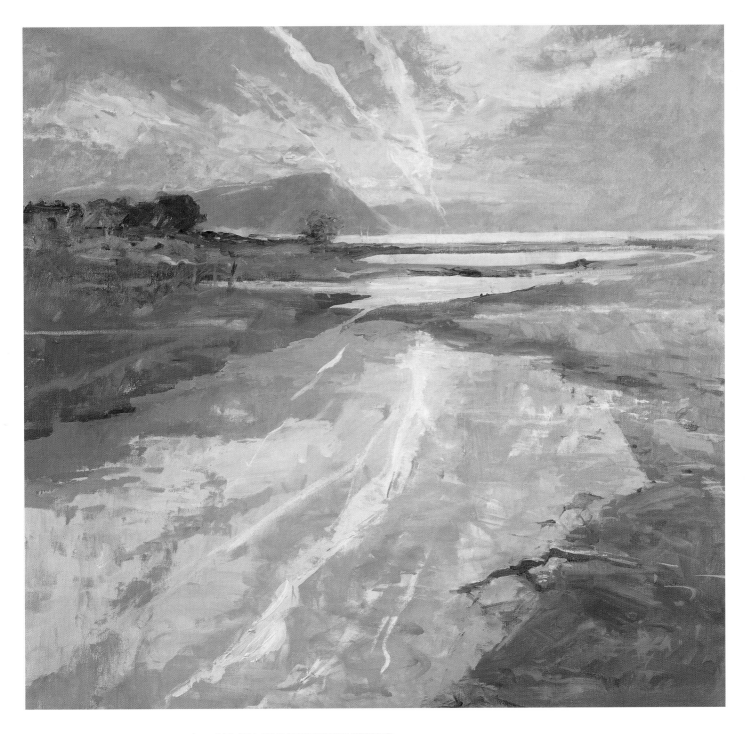

JET TRAILS OVER THE NEVERN ESTUARY
Oil on canvas, 91.5 x 91.5cm (36 x 36in)

From another viewpoint later on, when the tide had come in and the shapes had changed, I saw the painting, or I suppose the perfect natural composition, that I wanted. The jet trails were bright 'V' shapes, creating an obvious arrow pointing to the sea and the line of the horizon, which deliberately divides the composition one-third of the way down. I often compose paintings using 'thirds'.

61

KENSINGTON GARDENS
Oil on canvas,
86.5 x 96.5cm (34 x 38in)

I immediately liked the obvious formal arrangement of the Italian Gardens. Here again the horizon is about one-third of the way down the picture area, and other shapes, too, seem to correspond with a 'Golden Section' composition. But this composition was more instinctive and 'as seen' than deliberately planned.

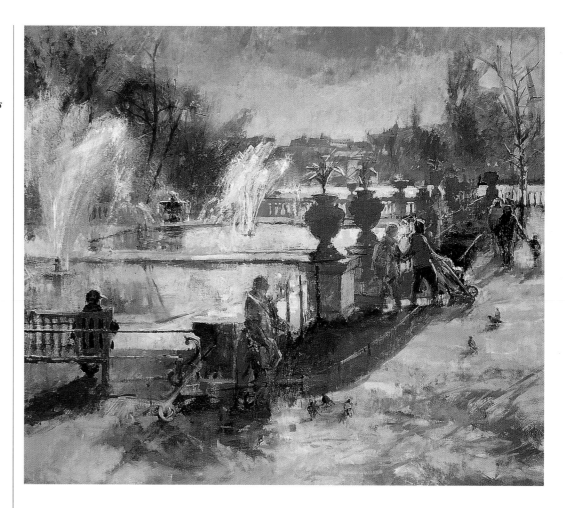

that I gained as a student. Today, when I have a problem with the composition of a painting I often return to the geometry and theory to help me work things out. However, on the whole I arrive at a composition in an instinctive way rather than by relying on set techniques and theory. As with subject matter, I firmly believe that there should be something about the composition that is discovered and developed in the painting process. Simply reproducing a preconceived plan or structure can result in a dull and uninspired painting.

Composition is all about balancing one thing against another, something we do all the time in our everyday lives. We like to organize a room or a garden, for instance, just as we will straighten a picture or rearrange ornaments. Visually, and I suppose psychologically, we prefer order and harmony. In a painting, achieving an interesting composition can be quite a complex business, because it involves not only the relative 'weight' and position of different shapes but also how these correlate with tone, colour, texture, line and other qualities. I have mentioned harmony, which is important in a general sense, but I would not want to give the impression that by virtue of this a good composition has to be symmetrical and balanced. In fact, complete symmetry, where one thing exactly balances another, is something I deliberately avoid because it is bound to result in a rather unimaginative arrangement. I am careful that I do not let the composition become too regular, in other words echo one shape directly opposite a similar one. Experience helps one to discover that there are plenty of exciting ways of creating order in a composition, at the same time directing the eye on an interesting journey through the painting.

ITALIAN FOUNTAIN, KENSINGTON
GARDENS
Oil on canvas,
127 x 71cm (50 x 28in)

These canvases were part of a commission to paint the London Parks for the Capital Club in London. They were conceived to fit the thin panels that divide up the large dining room at the club. Each painting was so designed that it could be viewed individually, yet at the same time formed part of a composite work. Consequently, although the left-hand canvas was painted first I was already thinking of how the composition would relate to the next panel, and so on.

So, the rules of composition can be helpful but should not become a rigid formula applied to every painting. I like to experiment with different arrangements, and take a chance with composition. For instance, sometimes I sketch in vertical, horizontal and diagonal guidelines on my canvas and devise an arrangement that includes a figure or other shape positioned right in the middle of the picture – which is obviously something totally alien to everything we are taught about good composition. What I place there may be painted in a subtle, half-hidden way and will certainly be outplayed by something else-where. But it does show that, with thought and care, the accepted rules of composition can be broken, and without disastrous consequences!

I hardly ever square up a canvas and transfer the design from a composition sketch in this way, preferring a much freer approach. But, as I have said, I will use a series of weak, brush-drawn lines and marks to help me plot out the underlying framework of the com-position and so establish some references from which to start building and developing the painting. For me, an effective composition is one that enables the painting to be created and viewed in an interesting way, yet is not obvious. If people notice a clever design rather than a well-painted picture then something is seriously wrong: the composition has become too dominant.

A very busy composition seldom works. Generally speaking, passages of strong colour or intense interest need balancing with areas of calm. However, it can be neces-sary to strengthen a composition by exaggerating certain aspects of the subject, and for me this is probably the limit of any artistic license. I will focus on some things at the

S. MARIA D'SALUTE, VENICE,
EVENING MASS
Oil on canvas,
61 x 25.5cm (24 x 10in)

Here, because I wanted to
paint the evening mass as the
subject, I intentionally put the
window with the red curtain
in the centre of the picture to
lead the eye straight to the
figures. The curves of the
arches above are echoed and
balanced by the circular motifs
of the floor below.

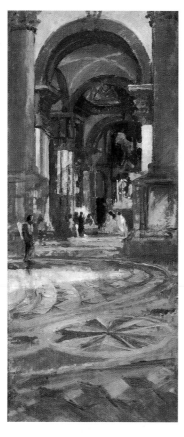

Opposite
INTERIOR SALUTE, VENICE
Oil on canvas,
96.5 x 66cm (38 x 26in)

By contrast, in this painting
of the same interior (see
opposite) I was more interested
in the architecture of the
building than the action
taking place. The perspective
was difficult, as the side
chapels were at odd angles
to the centre, and I had to
rely a great deal on drawings
and measurements.

expense of others and try alternative viewpoints, but I never distort the truth by conveniently inventing an object or moving something to a different position in order to improve the composition.

A successful composition will have a unity and variety created by the way different shapes, colours and other elements and techniques are used. In achieving this, contrast, movement and rhythm are important, and repetition can also be a useful device. Turner, for example, liked to repeat colours and shapes in many of his compositions, perhaps varying the scale and intensity, and by so doing he created very bold and exciting paintings. A good composition must also contribute to holding the viewer's attention and so encourage them to look more and more at the painting, and thereby discover new depths and qualities.

While I avoid planning a composition in every detail, I do believe that some preparatory work is essential, and I will make composition roughs in order to help me clarify the layout of the main shapes and decide on the general focus and emphasis in the painting. As I work, composition is always at the back of my mind: everything seems to relate to it. Even when I am making sketchbook notes or preliminary oil or watercolour studies I find that I will instinctively emphasize the diagonals, verticals and so on that might be useful in creating a balanced structure in the eventual painting.

Later, when I start work on the actual canvas, initial sketches and thoughts provide a good reference and starting point. As the painting progresses, I may change the composition slightly if I need to reinforce what I want to say about the subject. But I never make drastic changes, which in effect would create an entirely different painting. Through the painting process, as fresh colours are added and further shapes resolved, I will constantly check and evaluate the composition to ensure that it is working in the way I intended. In my view a successful painting relies more on a consideration of the overall design than on its individual parts. It is true that each part must be effective on its own, but equally it must work in relation to those around it and to the whole.

As an aid to selecting a subject, finding the best viewpoint and checking the bare bones of a composition, I often use a cardboard viewfinder or a camera viewfinder. This acts like a frame and enables me to isolate a possible subject from the surrounding area and judge how the principal shapes, tones, angles and so on will work in a painting. By using the telephoto lens on the camera I can zoom in or out to try different composition possibilities. Usually I prefer subjects in which the interest can be focused in the middle ground rather than the foreground. I find this not only creates a useful contrast or counterbalance in the design but also helps in conveying a sense of space and depth. But a foreground need not look empty and dull. There is scope for exciting paint-handling effects involving subtle changes of colour and texture, and this area very often includes shadows and other features that can be used to lead the eye into the painting.

For a representational artist, composition and viewpoint are more or less inseparable.

I often like to paint the same
or similar objects in both
watercolour and oils. This
still-life painting and the one
on the opposite page were
arranged on the same table
in the conservatory and both
are lit strongly from above.
The watercolour is painted
in a very free manner as
I wanted to explore the
possibilities of light.

So, in the preliminary work for a painting, especially if it is a landscape, I will try a number of different viewpoints to discover what composition possibilities there are. Looking and observing in this way also helps me notice interesting qualities in the subject that I can develop, and it encourages me to question exactly what I want to include. If I am painting the harbour at Porthgain, for example, I might have to decide whether I want to make something of the entrance to the harbour, which breaks the flow of the harbour wall and creates a dramatically contrasting pool of light, or whether this would be too obvious, too much of a 'stopper' in the overall composition. Should I instead concentrate on the strong diagonals of the high cliffs and buildings to the left? It may be that I only have to adjust the viewpoint slightly, but exploring different options is essential, I think.

Colour and tone are also important, though here again they need to work sympathetically with other elements within the composition. It could be that variety and balance can be developed by using, say, complementary colours or by emphasizing the light-against-dark aspects of a subject. In fact, the estuary paintings shown on pages 60 and 61 are as much to do with balancing colour as with using directional composition. Sometimes I think we get confused about how to interpret mass and space, believing that the only way to do this is through the use of perspective. But colour is also an excellent means of translating form and suggesting depth. While paintings cannot succeed without due thought to the composition, this need not involve perspective, as many beautiful pictures throughout the history of art clearly demonstrate.

Among the other factors that have to be considered in composing a painting are subject placement and focal points. Various 'rules' can act as a guide here – as, for example, not placing the subject exactly in the middle of the canvas, or not using diagonals and other directional lines that go right to the edge of the painting and so carry the eye out of the picture area. These rules act as a check on how one develops the composition but they need not be scrupulously observed. The subject itself will often suggest ways of leading the

viewer's eye around the picture and arriving at a focal point. For example, in *Kensington Gardens*, reproduced on page 62, I have made use of a strong perspective diagonal, emphasized by a shadow, counteracting this with a number of horizontals. In contrast, in *Italian Fountain, Kensington Gardens*, shown on page 63 (right), much of the interest is focused down the left-hand side, with the light area forming a sort of L-shaped composition.

In all my pictures I ensure that the eye is led to a focal point or centre of interest. In a landscape or townscape the focal point is often a figure, while in an interior it could be a particular object or a patch of light. In *Interior Salute, Venice*, shown on page 65, the sweeping curves of the floor decoration lead the eye into the centre of the painting and so up to the patch of red light in the window, which makes a striking focal point. Incidentally, in all interiors and street scenes the perspective must be observed and drawn very accurately otherwise it will look unconvincing in a painting. I make careful preliminary drawings to help me understand any particularly complicated structures or perspective views.

I find it difficult to analyse objectively my way of composing pictures because, as I have said, although I have studied all the theory, and work with a knowledge and respect of this, I do feel that much of what happens in composing a work relies on experience and intuition. In many paintings composition is also a matter of trial and error before a satisfactory arrangement of shapes, colours and other elements is achieved. Every painting situation is different and in composition, as in any aspect of painting, there are always opportunities to try out new ideas.

CONSERVATORY TABLE
Oil on canvas,
51 x 71cm (20 x 28in)

The watercolour shown on page 66 was used as a reference for this oil painting, but I also added different objects and brought out the trellis-work in the background to echo the shape of the shadows.

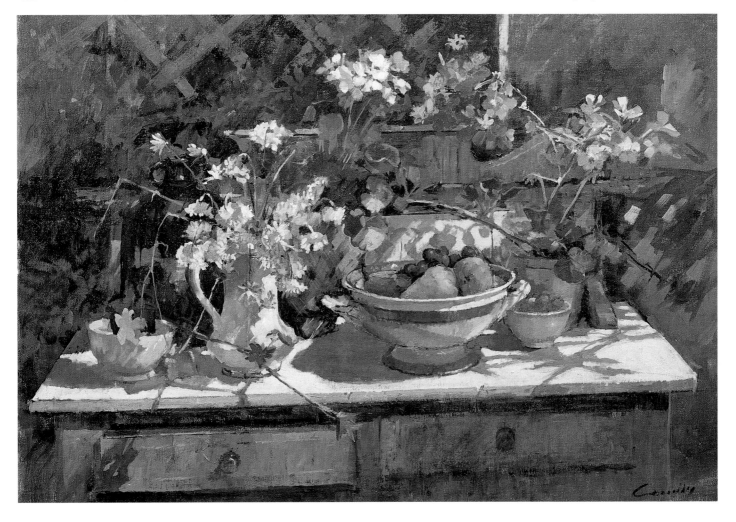

COLOUR AND LIGHT

In everything I paint, whether it be a landscape, interior, still life or portrait, it is usually the special quality of the light that interests me most. Essentially, light is the inspiration and motivation for my painting. Invariably my initial attraction to a subject is because of a particular type of light, and subsequently, as I develop the painting, my main concern is with capturing the specific effects of light and through these revealing my thoughts and feelings about the subject. In my view it is always the light, in one of its many forms and varieties, that gives a subject its unique mood and impact.

Conveying the character and effects of light does, of course, rely on an understanding of tone, which in turn has to be expressed through colour. This sounds complicated, but the way I approach it is first to think in terms of the lights and darks, in other words to observe and concentrate on the tonal qualities of the subject, and then gradually introduce more colour in such a way as to translate and develop the tones. So initially I am considering the relative lightness or darkness of something, irrespective of its colour. When I was a student I remember being told to think of the tonal scale as a piano keyboard. The light tones are the high notes and the dark tones are the low notes, with a range of gradated tones in between. But in handling different tones, as in all aspects of painting, it takes time to build up confidence. Initially it is easy to be deceived by preconceptions about the colour of something, and we have to learn how to distinguish the tone of an object from the colour we know it to be.

A consideration of the tonal qualities of a subject is obviously very important, but I think one has to be careful not to place too much emphasis on this, for there is always a danger that it can become an inhibiting factor in a painting. Another point I like to bear in mind is that while most paintings benefit from strong tonal contrasts, too many different tones tend to create confusion and visual discord. For example, the range of lights to darks in a landscape is normally so wide that I have to limit it and decide whether I want to work in a high key, with light tones and colours, or a low key, with dark tones and colours. In oils I usually find it best to start in a low key because if, for instance, I were to begin by putting in some pure white there would be nothing left to lighten. *English National Opera, Faust*, which is reproduced on page 73, is a case in point. At first glance the music sheets look very light, but when they are seen against a sheet of white paper they are in fact a yellow-grey.

I am particularly fond of subjects which have an inherently strong tonal contrast, for I like to work from the tones that I can see, rather than invent or exaggerate them. So I will not, for example, dramatize a sky effect or add sunshine and shadows if they are not there. However, once the painting begins to take shape I may decide to adjust the tonal range if I think this is necessary in order to convey a more convincing sense of space or feeling for mood and atmosphere. Sometimes the darks need to be a little more intense, for example,

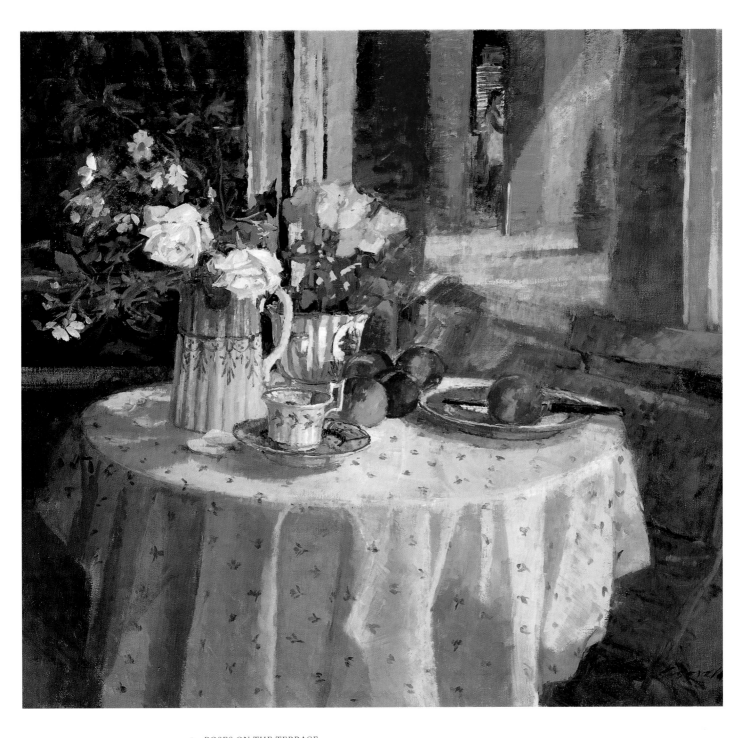

ROSES ON THE TERRACE
Oil on canvas,
66 x 76.5cm (26 x 30in)

As here, colour and light are often the main factors in linking a composition together. In this still life the placing of the various blues and reds, combined with the play of lights and darks, helps to lead the eye across and around the painting.

MORNING LIGHT, NEW YORK
Oil on canvas,
168 x 66cm (66 x 26in)

This was a commission, the
only proviso being the shape.
About that time I had been
working on studies for a still
life arranged on the table in
front of my window in New
York, and this unusual shape
gave me the idea for the
painting. I wanted it to have
a light, decorative feel about it.
The light was filtering through
the buildings and trees, but it
was a soft, spring light and so
the flowers and other objects
were not aggressively contre
jour *but remained in a cool*
mid-tone.

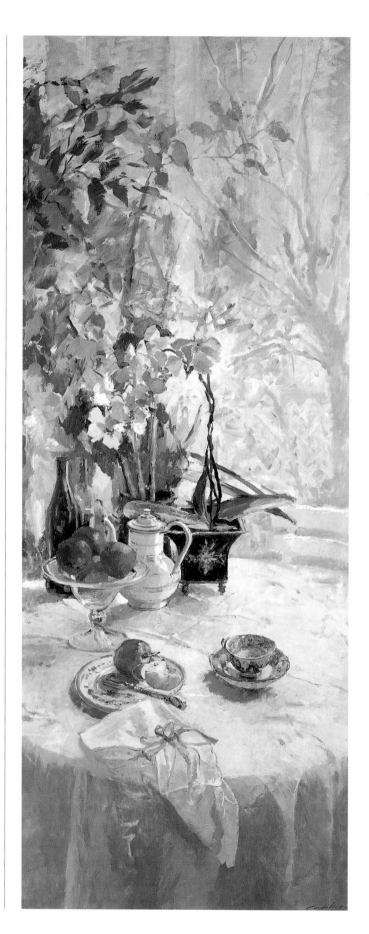

70

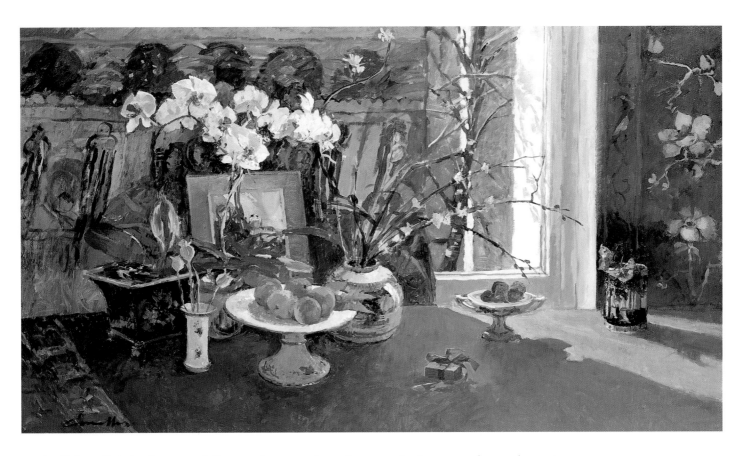

or the lights slightly sharper, while on other occasions the opposite is true and areas have to be toned down so that there is better harmony within the whole composition. Incidentally, although tone is a vital consideration, especially at the beginning of a painting, it is of course not the only quality to think about. In any stage of a painting one is juggling with various elements and concerns, and all the while checking how these relate to each other as well as to the overall composition and the aims for the work.

In oils, I often begin with a tonal underpainting made by loosely blocking in the main shapes and areas with a fairly diluted mixture of burnt umber and perhaps a little ultramarine. I make constant reference to the light and dark values in the subject before me, and while this initial painting is still wet I might weaken some areas by wiping them with a rag, or I may decide to strengthen other parts by adding more paint. This approach gives me a general feeling for the distribution of lights and darks and helps me to observe and think tonally, so that I am already beginning to relate tone to colour. Assessing tone becomes instinctive after a while, but always a useful aid in judging relative tonal values is to half-close your eyes. This helps block out the distractions of colour and details and thus enhances your perception of tone. With watercolours I adopt a similar approach, again initially thinking in terms of different tones, but with this medium one obviously has to consider the lightest areas first and gradually build up the darks.

Mixing a colour of exactly the right tone can be a difficult process; indeed, resolute trial and error is sometimes the only way! Very often colours look fine when freshly mixed on the palette, but once applied to the canvas and seen in the context of the surrounding colours they may need further modification. In fact, interpreting light successfully requires a constant process of looking, colour mixing, painting and reassessing. For most paintings I set out the same range of colours on my palette (as explained in Chapter One

MY FAVOURITE THINGS
Oil on canvas,
132.5 x 81.5cm (52 x 32in)

This lower-toned, more sombre work was painted for the same patron as the still life on the opposite page. The only stipulation here was that as well as painting all my favourite things I had to include a butterfly! I loved this bit of fun and enjoyed trying to paint butterflies on the move – when I could tempt them inside! Apart from this it was a serious work, with a great deal of thought given to the composition.

INTERIOR, THE DANIELLI, VENICE
Oil on canvas,
40.5 x 30.5cm (16 x 12in)

I painted this from a number of studies of the upper hallway that I made while visiting the Danielli Hotel in Venice. I particularly liked the rich, gloomy interior with the contrast of the dark chandelier against the one that was lit, and the striking blues and oranges. However, paintings by artificial light always need careful consideration so that the colours do not take on a yellow hue.

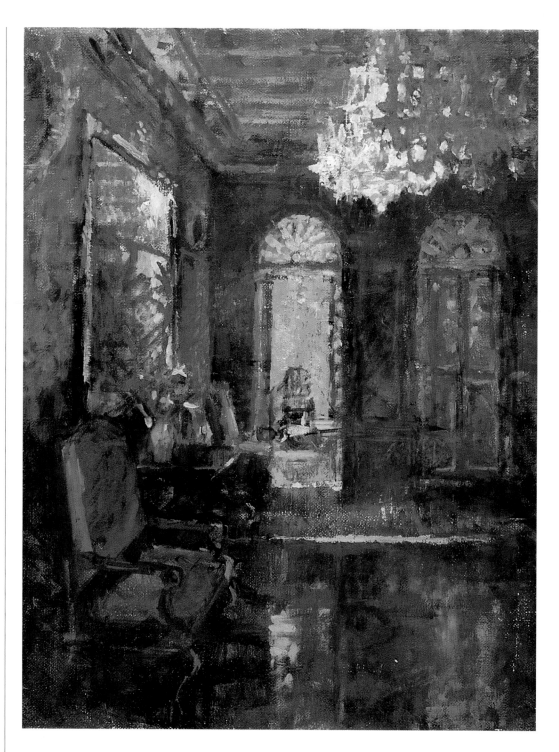

and Chapter Two), although occasionally I add a particular colour that I will need, or I may experiment with one or two new colours. However, I only actually use those colours that are appropriate to the subject matter, colour and tonal key, and that could be quite a limited number. Each colour on the palette has an inherent tone, of course, with yellow, for example, being a naturally light-toned colour and purple a dark-toned one. But it is very unlikely that a colour straight from the tube will be right for a painting, and so most colours have to be carefully mixed to create the desired hue and tone.

While it is essential to know how to analyse subjects in terms of lights, darks and mid-

ENGLISH NATIONAL OPERA,
FAUST
Oil on canvas,
51 x 61cm (20 x 24in)

I have always been interested in the interiors of theatres and paintings of these, especially those by Degas and Sickert. Whenever I go to the theatre I take a little notebook or sketchbook. On this occasion I was sitting in one of the side boxes; I had taken along my pochade box and was able to paint a number of small panels that I clipped to the lid. There was just enough light from the stage to do this, but I had to analyse the darks very carefully to find the warm and cool tones. It is easy to assume that you are just seeing black, whereas in fact there are so many subtleties of this one colour to be considered.

tones in order to capture a particular kind of light and mood, equally an understanding of tone helps one to model forms and give the illusion of space and distance. In any painting a key factor is the source, direction and strength of light and how this influences different areas, consequently creating highlights, shadows and so on which in turn combine and relate to form an interesting composition. Again, in the actual painting process these two qualities, of interpreting light and conveying a sense of space, are inseparable, with each relating to and supporting the other. I have mentioned that sometimes I may need to emphasize or modify the tonal qualities in a painting. Here, handling the modelling and the pattern of light and shade in an effective manner is also linked with harmony and counterpoint – the use of tonal similarities and obvious tonal contrasts.

Many of my landscape subjects have an inherent, low-toned colour harmony. This is because the colour range is limited mainly to greens and therefore, being confined to a single colour, the different hues and tones create a natural harmony, unifying the various shapes and forms in the composition. However, whenever I work with a fairly limited palette I am very conscious of the fact that too much harmony can result in a rather unexciting painting, and so I always try to find subjects in which I can counter harmony with a little contrast. In fact, a limited range of colours can provide harmony and contrast, for example by exploiting the different intensities of cerulean, ultramarine, cobalt and French ultramarine. But in general I like to involve a contrasting colour, as I have done in

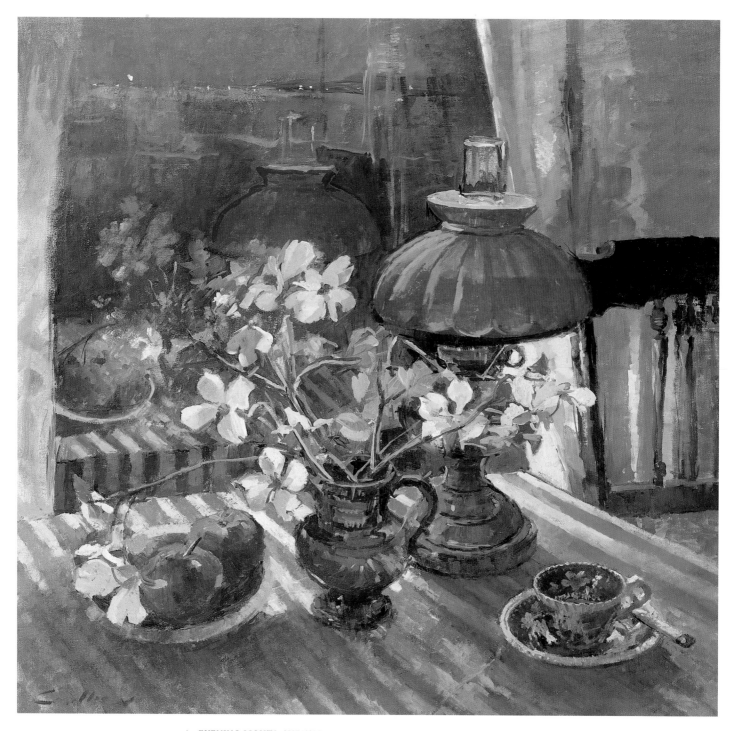

EVENING LIGHTS, SHELTER ISLAND, NEW YORK
Oil on canvas, 61 x 61cm (24 x 24in)

This painting, with the lamp reflected in the window and the harbour lights from Greenport seen across the sound, was made one night when I was staying on Long Island. I had started the painting at dusk when I could still see the shoreline outside. But as it grew darker the reflections became more intense, and I then had to decide whether to change the painting or keep to the same scene but work on it for just a short while each early evening. In the end I decided to continue painting, and by that time the harbour lights had come on.

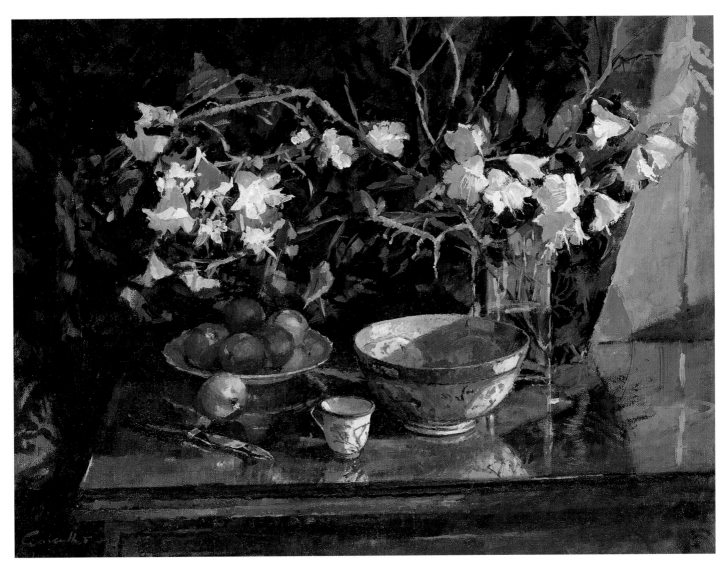

SPRING FLOWERS AND
NECTARINES
Oil on canvas,
51 x 66cm (20 x 26in)

Winter Light, Kensington Gardens, reproduced on page 83, in which the overall low-key colour is contrasted with an area of warm colour in the sky. Similarly, in my still-life paintings I frequently use a colour or sequence of colours as a unifying link throughout the composition while including one object or area which provides an opposing, complementary colour. Here also I should point out that colour, light and tone should all work together, and so another way of creating contrast is through the use of, for example, rich, dark shadows in an otherwise light or mid-toned subject.

A technique that is useful for creating certain lighting effects is tonal counterchange, which is the placing of light shapes against dark and dark against light. Sometimes I like to use very bold contrasts of tones, as, for example, in a *contre jour* subject where shapes are viewed against the light, but on other occasions tonal counterchange is more effective if the contrasts are less obvious. Where there are highlights and more subtle effects of light I like to use 'lost' and 'found' edges, letting some shapes blend with their surroundings and contrasting these with others that are well defined.

When considering lights and darks, tonal counterchange and so on, I am at the same time considering colour, of course. What I learned about colour as a student has since been enriched by the experience of painting a great many pictures, and thus my response

The source of light for this still life was from the window, but in order to keep the light constant it was also necessary to use a daylight spot lamp. In this way I could continue working even though the sun moved round.

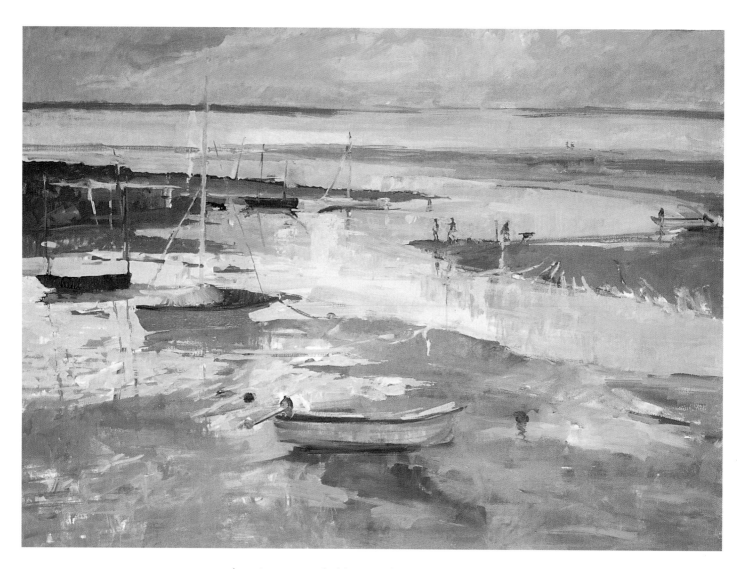

NEWPORT, SUNSET
Oil on canvas,
91.5 x 122cm (36 x 48in)

*I painted this large canvas
using a very limited palette of
just six colours. I wanted to
keep it as simple as possible to
capture the particular mood
and atmosphere of the scene.
As most of the light was on
the water, I placed the horizon
high on the canvas and the
zig-zag of river right in
the centre. Once again I
was conscious of using
complementary colours to add
brightness and movement.*

to colour is now probably mainly intuitive rather than calculated. But whether I make decisions about colour consciously or subconsciously, I naturally involve the use of complementary colours, colour harmony and other devices and techniques where these are appropriate. For example, I find that, used with discretion, a complementary colour will add a touch of drama and impact to a work, especially a landscape. This is the case in *Summer, Hyde Park*, reproduced on page 80, in which I have included a few touches of red among the greens. However, usually I like to use colours that are almost complementary, such as a blue/green and an orange, rather than direct complementaries, which can appear very harsh. Having said this, the exact opposites can be successful if the colours are tonally compatible, as in *Interior, The Danielli, Venice*, reproduced on page 72, in which the striking blues and oranges seemed to work well together. But in general I think complementary colours work best as small accents of colour to enhance areas or create contrasts, and they are also useful when considering the colour of shadows.

There is no guaranteed or easy way to paint a certain effect of light, and in any case every subject and type of light is different. Capturing the light and mood of a subject is firstly a matter of observation and then one of technique, of using the right colours, creating the correct colour and tonal relationships, and considering the consistency and surface quality of the paint. I find that in both oils and watercolours the process of developing a

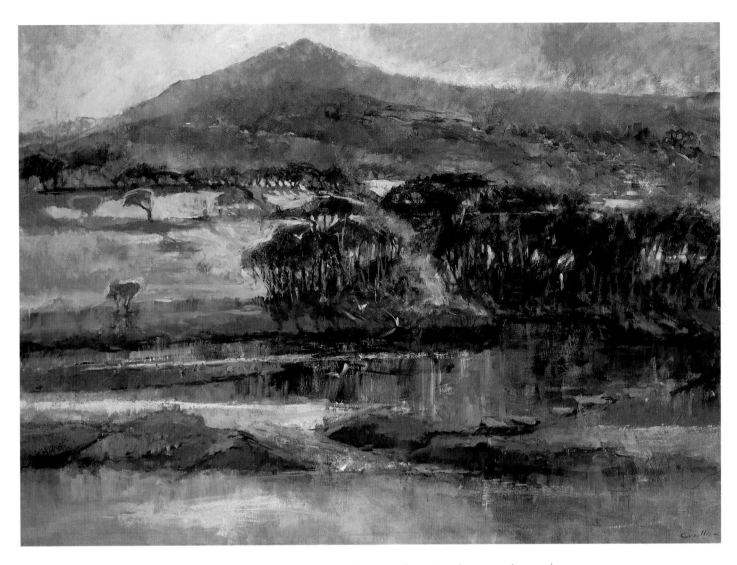

special light effect has to be a gradual one, slowly building up the paint layer on layer. This is not to say that paint has to be thick or that areas cannot be lifted out or scraped back and reworked – it is a question of constantly assessing and readjusting what I am doing. As I have implied, for some light effects success depends on creating a particular surface texture. To convey the effect of light on water, for example, as in *The Estuary, Winter*, reproduced on pages 78 and 79, I will often put colour on and then scrape it off, thus making a broken, translucent texture in which some of the original colour shows through the newly applied paint. Another technique, used where a broken or mottled light and dark effect is required, is to gently drag a brush laden with fairly dry paint across a chosen area.

It is easy to assume that really dark areas are black, but what appears to be black is usually a subtle mix of warm and cool tones. I seldom use black. For a strong dark colour I mix raw umber and ultramarine. This can be warmed slightly by the addition of some rose madder, or cooled by mixing it with a little viridian. In the same way a pure white is often rather stark and uncompromising, so whites generally look more convincing if they are tinted slightly with another colour, perhaps with a very small amount of a yellow (warm) or a blue (cool). Light colours appear much more intense if set against their complementary colour, but will seem more subdued if surrounded by an earth colour or

AFON NANHYFER, PEMBROKESHIRE
Oil on canvas,
91.5 x 122cm (36 x 48in)

This is the river that flows into the estuary at low tide, and I wanted to capture the whole feeling of that area in the late September light. With the sun behind Carn Ingli the shadows and reflections were quite distinct, despite the hazy quality of the light. I found it interesting that Newport, Sunset, *reproduced on the opposite page, was the more colourful painting, even though I used fewer colours.*

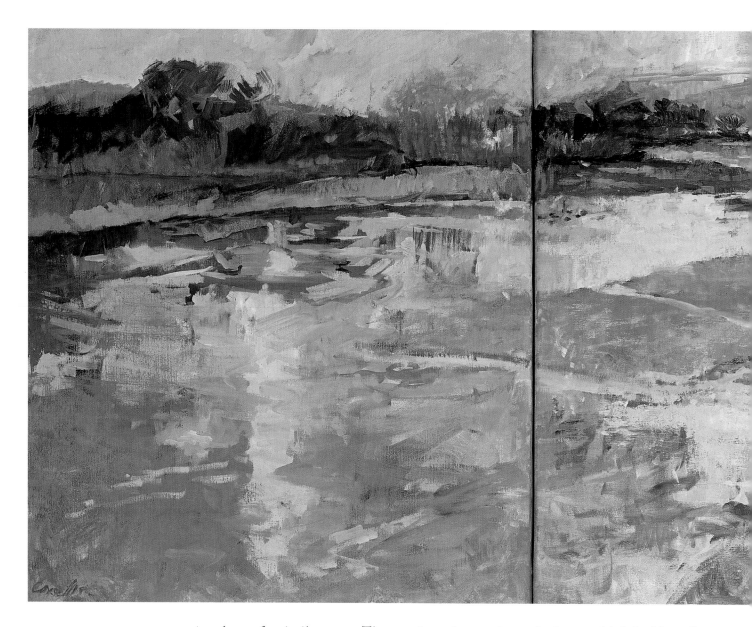

colour of a similar tone. These points also apply to shadows, which incidentally are normally not nearly as dark as they look. But if you make shadows too blue they will jump forward, so it can take a lot of adjusting and readjusting to create shadows that are of just the right tone and therefore look flat. In the main it is true that the colour of a shadow is usually a darker version of the local colour (the colour of the surface it falls across), but invariably a shadow colour also contains the complementary colour of the object or surface on which it is seen.

One of my favourite kinds of light is *contre jour*, where I am looking into the light and therefore the subject is in partial silhouette. This creates a strong contrast between the low-toned foreground subject and the bright light and warmer key of the background. I have always been interested in low-toned subjects, and in *contre jour* I like the idea that forms and features are simplified and that much of the painting involves a sequence of greys, which I find really challenging and enjoyable. I am intrigued by the colours contained in greys, and I will often experiment by adding other colours to the basic blues and ochres in order to find exactly the grey I need for a particular part of a painting.

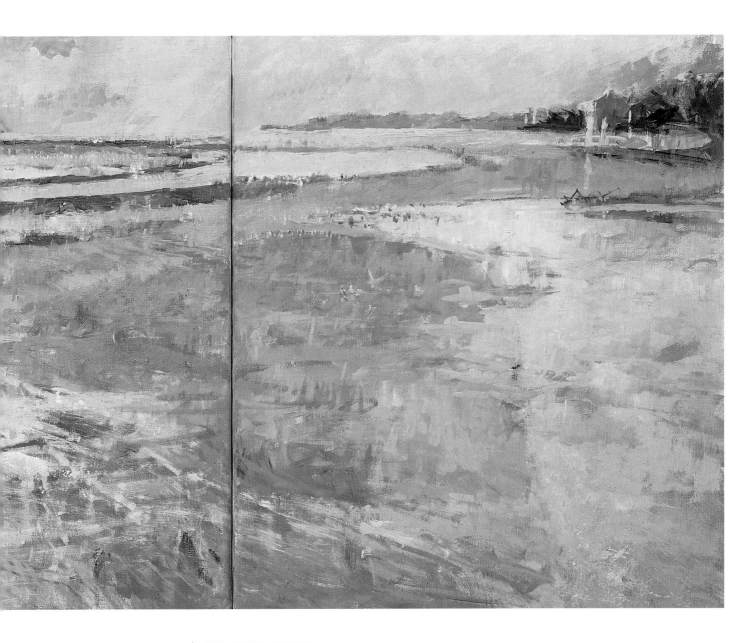

THE ESTUARY, WINTER
Oil on canvas, 51 x 153cm (20 x 60in)

*This, my favourite estuary, was painted in January when the
low winter sun had that special sparkle in the cold air. The light
hit the surface of the water literally in spots and dashes, broken
up and interrupted by stones and emerging river bed. It is really
a subject of nothing, just an almost empty area, but because of
the light and reflections it becomes alive and is full of interest.
The composition of the painting was not difficult because it was
all there in front of me, the patterns and shapes naturally leading
the eye right into the distance.*

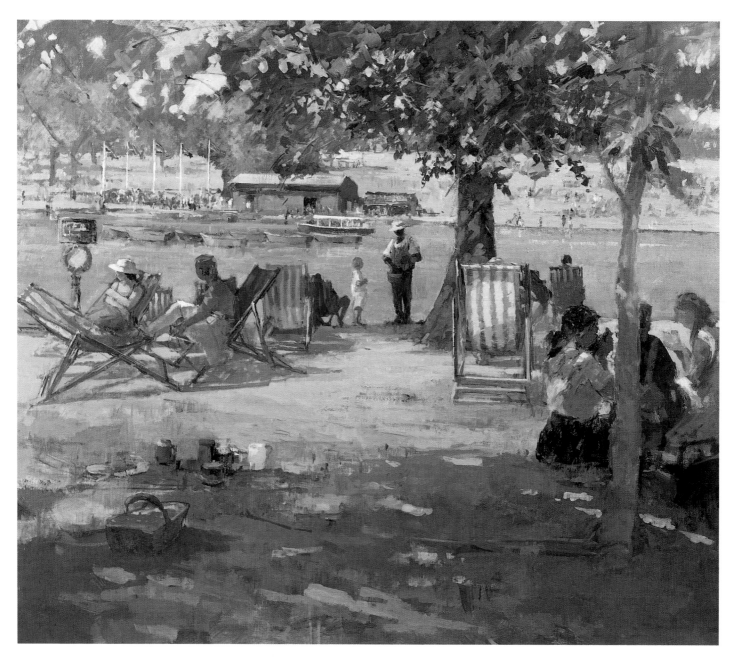

SUMMER, HYDE PARK
Oil on canvas, 81.5 x 91.5 (32 x 36in)

This was painted during a heatwave one August in London, when the grass had become dry and bleached and everyone wanted to be in the park in the middle of the day. I loved the mixture of low and high tones, the shadows, and here again, the almost muted colours, proving that to depict bright light it is not necessary to use a wide palette. To prevent the blues and greens from becoming too cold I have mixed them with umbers and ochres. The few reds are used just to give essential accents throughout the painting.

In *contre jour*, as in all landscapes and subjects painted by natural light, one of the main difficulties lies in ensuring consistency in the lighting conditions. I find that studies, watercolours and smaller paintings can be completed in a single session and so the light is more or less the same, but with larger canvases the only solution is to work for a limited period, and then to try to catch the light for the same few hours over the following days until the work is finished. But whatever the difficulties, I love painting light in all locations, weathers and situations. A still life lit by lamplight can be fascinating, as can a dramatically lit interior or a landscape seen in the weak, clear light of midwinter. In my view, understanding light and being able to interpret that understanding through a particular handling of paint is the key to success with all subjects.

SUMMER PICNIC, KENSINGTON
GARDENS
Oil on canvas,
71 x 91.5cm (28 x 36in)

The things that especially interested me about this subject were the dappled sunlight, the groups of figures, and the fact that there seemed to be three natural horizontal divisions to the composition: the bridge across the Serpentine, the light pathway in the centre, and the shadows from the trees in the foreground.

Above
BY THE ROUND POND, KENSINGTON GARDENS
Oil on canvas, 71 x 81.5cm (28 x 32in)

This was painted in autumn: the leaves had turned and the whole park glowed in the late afternoon sun. To create the light and warmth in the foreground areas I have rubbed colour into the underpainting with a rag.

Opposite
WINTER LIGHT, KENSINGTON GARDENS
Oil on canvas, 122 x 91.5cm (48 x 36in)

Here, the cold, still atmosphere in the park after a brief snowfall contrasted with the warmth of the sky colour and the few remaining autumn leaves creating areas of soft brown against the blues. Something that particularly interested me was the way the bark of the silver birches made patches of dark against light and then light against dark.

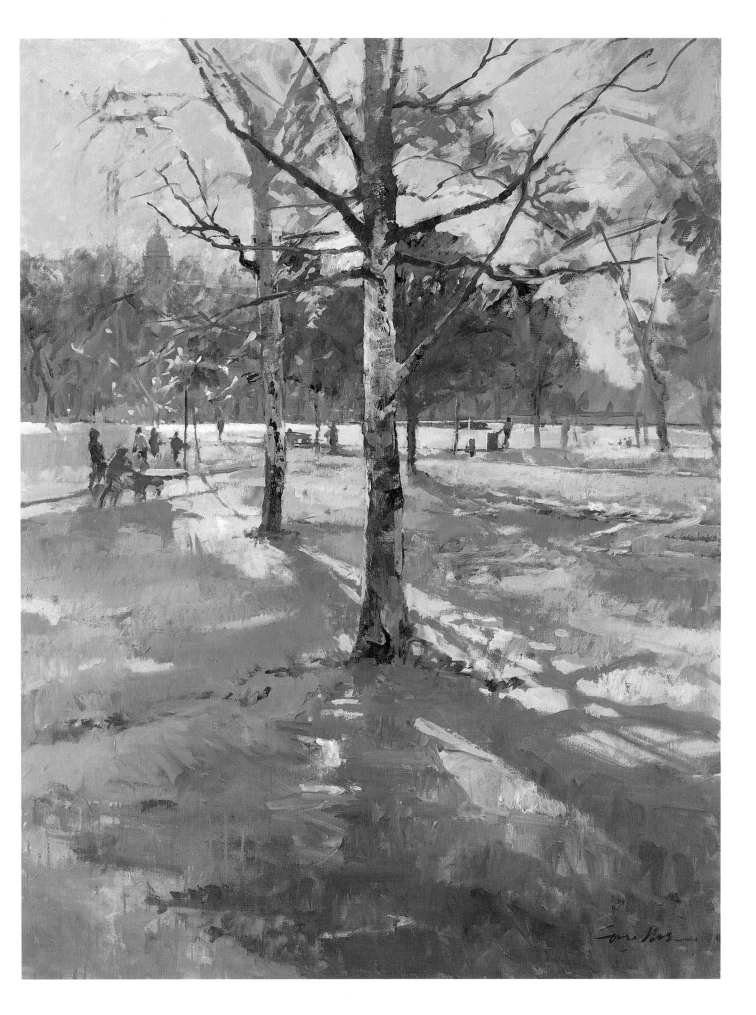

Chapter Six

INTERIORS

For me, the appeal of an interior is more to do with a feeling for the space or room in general rather than a particular interest in its contents, and my response is usually instinctive. There are no special qualities and features that I actively search out; instead, my choice of subject matter depends on the reaction that different interiors provoke in me, and this is something I cannot judge until I am actually there, within the room. However, invariably it is subjects which have a strong sense of mood and atmosphere that most appeal, and usually these qualities are determined by a certain type of light. I especially like ideas in which there is a contrast of unexpected light with really dark shadows.

The first interior I remember painting was when I was a child. I was keen to have my bedroom redecorated and my mother had asked me to make a painting to show what I wanted. Much later, at art school, I had to paint many formal compositions, indeed one every week. These paintings were influenced by Vuillard, Bonnard and Sickert: I admired the texture and pattern in Vuillard's paintings, the Mediterranean palette of Bonnard, and the low tones and muted colours of Sickert. I painted interiors with and without figures, and sometimes including a still life. Also during my art school days I painted many life studies in the studio, where I used to relate the figure to the surroundings and so create 'figure in interior' pictures. Paintings of almost empty rooms came later on, when I became more interested in shapes and textures and the atmosphere or 'story' of a subject.

Ordinary rooms can be interesting, and I often come across ideas where the drama of light and dark can create a powerful image from what is actually quite a simple composition. Painted *contre jour*, *The Evening Meal, Malaysia*, reproduced on page 90, is a good example of this type of subject. I occasionally paint in other people's houses, and if only I could find the time, I would love to try several possible interior subjects that I have noticed in my own home. However, I suppose in general I find the greater sense of space, history, architecture and décor in a palazzo, villa, church or similar building much more exciting. Often in such places the flaking plaster, faded curtains, broken shutters or other aspects of decay and dilapidation add to the charm. And even if the room is uncomfortably hot and difficult to paint in, I am happy to persevere, especially if I have discovered it at exactly the right time of day, full of mood and atmosphere.

A characteristic feature of many interiors is their timeless quality. Nevertheless, I think it is important to capture an interior at a certain moment in time. Maybe the sense of timelessness is one reason why interiors have become much more popular with collectors in recent years. Something else which may influence people's interest in this subject is the fact that we spend most of our lives in rooms of different kinds and therefore cannot help but relate to interiors in some way. Not surprisingly, this genre features throughout the history of art, from, and no doubt preceding, the wall frescos in Pompeii, which show

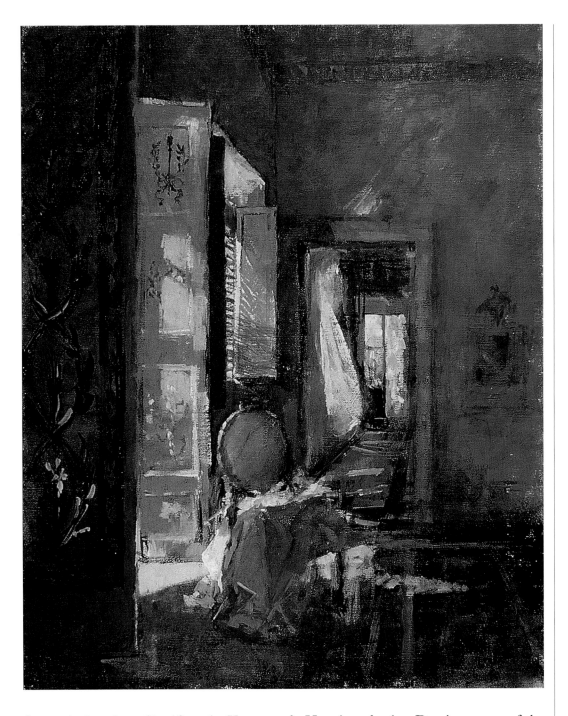

VILLA PARDINI, LUCCA,
TUSCANY
*Oil on canvas,
46 x 35.5cm (18 x 14in)*

This started out as a study for a larger painting, and originally the door behind the chair was closed. But while I was painting, by one of those chance happenings someone opened the door and I saw the sunlit passage beyond. Another thing that interested me was the way the curtain fluttered in the breeze, and I decided to use this as a feature in the composition. It provided a natural way of leading the eye down, zig-zag fashion, to the light in the foreground. Like many of my interior subjects, this scene initially appealed to me because of the strong contrast between an area of light, interest and pattern, and one of calm.

figures in interiors. Significantly, Vermeer, de Hooch and other Dutch masters of the seventeenth century began to explore interiors as a subject in its own right rather than something subordinate to a religious or mythological main theme, while much later the interest of the Impressionists and modern masters was in colour, light and mood.

Because they are usually hidden behind closed doors somewhere, exciting interior subjects are obviously not as easy to find as, say, a Pembrokeshire landscape, which is there for all to view. So when it comes to finding good ideas I mostly have to rely on luck. Occasionally I look through holiday brochures to pick out a house that seems to offer interesting rooms and potential ideas, and then rent this with some friends. But this method is not always successful, although it does provide a starting point. Otherwise I

TWO MALACCA CHAIRS
Oil on canvas,
89 x 76.5cm (35 x 30in)

I was immediately struck by these two chairs left abandoned in an old house in Kuala Lumpur, for they surely had some tale to tell. That, combined with the lowered shutters casting an almost colourless light, created a scene of pure magic.

will plan a trip to a location that I think will prove rewarding and then rely on someone with local knowledge to recommend places to try.

This was exactly the case when I went to Venice in 1994. I arrived with no pre-planned itinerary of houses or villas to view and paint. Luckily, after a few days I met people who recommended places to look at and other people to contact. This is the approach I prefer. I think it is a good idea to force oneself to go away and paint because, apart from anything else, it creates a period of time in which you can focus completely on painting. I was fortunate to be able to stay in Venice for several months and to meet a number of people who lived in some lovely houses. The paintings I did of grand interiors encouraged me to look also at church interiors, where I found that the light, the space and in this case the human presence, were an equal inspiration. One subject invariably leads to another.

With interiors it is often a matter of being in the right place at the right time, of capitalizing on a moment. This is something that cannot be achieved in the studio, I believe. You have to be there, experiencing what is going on and relating to the scene.

THE SILK CHAIRS, PALAZZO
CONTARINI POLIGNAC, VENICE
Oil on canvas,
91.5 x 76.5cm (36 x 30in)

*In a way, this painting had
more in common with a still
life than an interior, but no
doubt these chairs also had a
story to tell. In fact, there
were about ten of them
arranged down the side of
the room underneath huge
plaster-framed mirrors.
I did a number of studies
and eventually decided to
concentrate on just these
three and the detail of the
plasterwork. The tattered
silk and the cracked plaster
add to the general feeling of
neglect and abandonment.*

Someone walking into a room, the sudden glow of sunlight through a coloured glass window, or just the flutter of a curtain somewhere can create precisely the nuance that will add mood and impact. When I was in one house in Lucca, for example, I came across a woman removing dust sheets from the furniture, and this was exactly the sort of interior 'moment' that I like to capture. The different light and cultures of each region of the world play their part, of course, in defining the ideas available. For instance, I found a great contrast between the light and interior subjects I came across in Malaysia, where I lived for a time, and those in Europe.

The most effective interior paintings, I think, are those that are kept simple. I like to make a fairly bold, straightforward statement which, although influenced by light, is uncluttered and conveys a powerful sense of space. If there is too much in the painting, either with regard to detail or concerning the main elements of the composition, then

THE WHITE NIGHTDRESS,
CHÂTEAU MOCQUES, FRANCE
Oil on canvas,
102 x 76.5cm (40 x 30in)

I started doing a small
painting in the inner room,
and it was only when I stepped
back to check on my progress
that I realized there was a far
more interesting subject from
beyond the doorway, with
the clothes hanging in
the wardrobe.

there is a danger of it all becoming confused, and the focus and impact of the idea will be lost. As always, it is a great temptation to put everything in, while it requires a certain discipline to leave things out. So I prefer an interior that can be painted more or less 'as found': subjects that do not need rearranging or significantly altering. Occasionally I move a chair, close a window, turn on a light or introduce a figure if this will help the composition or create a stronger mood. But I never make any drastic changes or 'compose' an interior in the same way that I would set up and compose a still life.

Similarly, in the actual painting, to help me capture what I feel about the interior, I

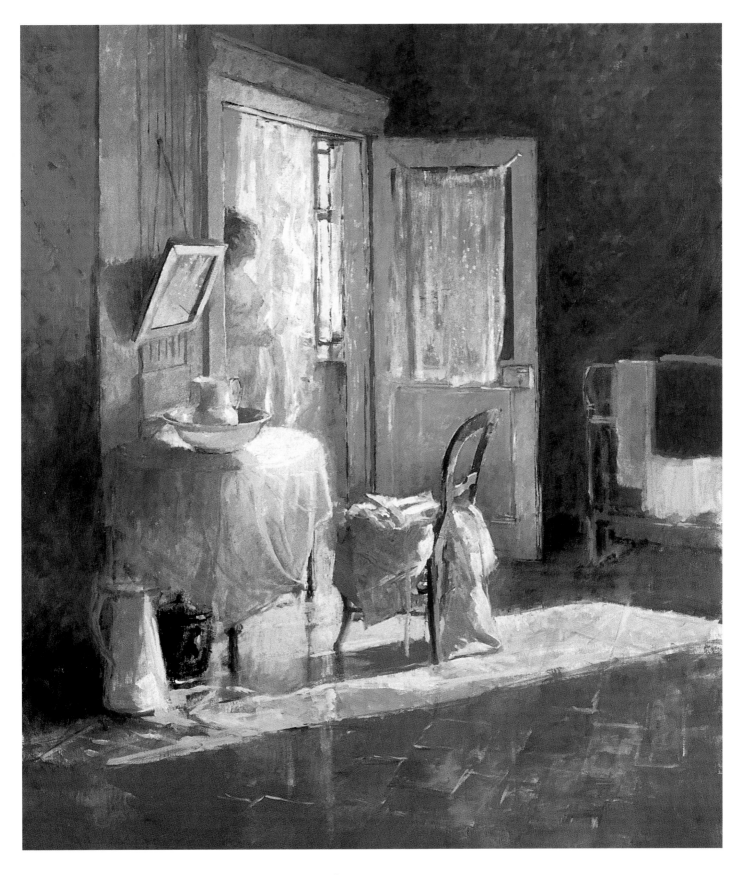

THE GREEN BATHROOM, CHÂTEAU MOCQUES, FRANCE
Oil on canvas, 91.5 x 81.5cm (36 x 32in)

In both this and the painting on the opposite page I was struck by
the contrasts of warm versus cool colours.

89

THE EVENING MEAL, MALAYSIA
Oil on canvas,
33 x 25.5cm (13 x 10in)

I found this a wonderful subject for contre jour, *with the figure so low-toned against the bright light. I particularly liked the lattice work in the windows, which was typical of the Malay houses, and this just added the essential balance to the top of the painting.*

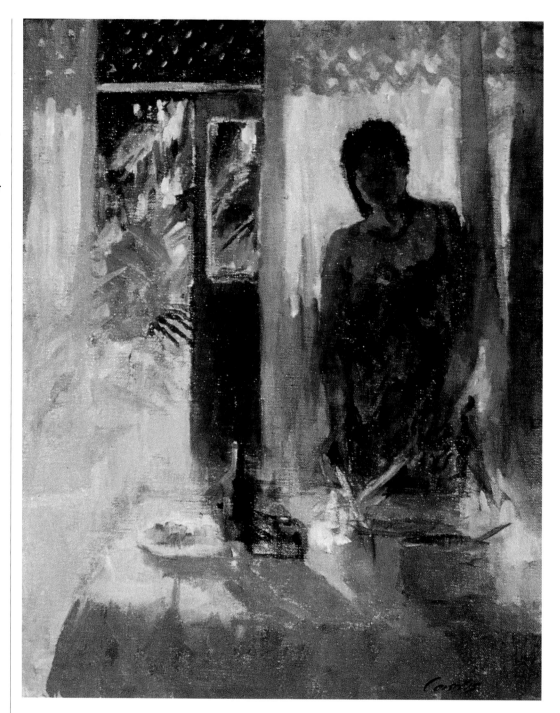

may need to emphasize some qualities, such as the light and dark values, while simplifying or reducing other aspects. However, here again I am careful not to take any personal reaction to the subject too far, certainly not to the extent of distorting or inventing things. Instead, my aim is to paint the subject before me in a sensitive, individual way and with, I hope, a particular feeling for light and mood.

Because I prefer to complete as much of the painting as possible on the spot, finding the right viewpoint is very important. Many of my interior subjects are based on the idea of looking into a room or at part of a room and the view beyond. For instance, I like the idea of looking through a doorway from one room into the next, and most of my Venice

interiors were painted in this way. Sometimes just a corner of a room makes a strong subject, particularly if it has a window or open shutters onto a balcony, and therefore a view outside. Taking a viewpoint facing a window gives me the opportunity to paint against the light or *contre jour*, which is something I greatly enjoy as it always offers lots of exciting possibilities for dramatic shadows and for bold contrasts of light and dark. Occasionally I use lamplight to cast dramatic shadows, too; however, on the whole I prefer to work in natural light.

Villa Pardini, Lucca, Tuscany, reproduced on

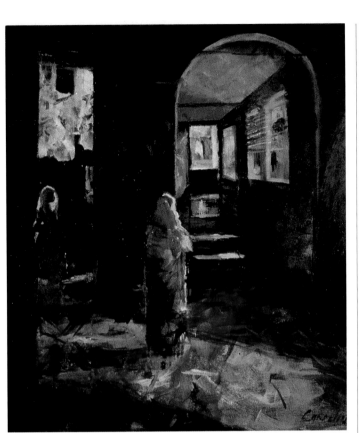

INTERIOR, KUALA LUMPUR, MALAYSIA
Oil on canvas,
30.5 x 25.5cm (12 x 10in)

I painted this shortly after I arrived in Malaysia. I wanted to create a sense of the hot, humid atmosphere and the distinctly Eastern, oriental character.

page 85, is a painting which embraces many of the ideas and qualities that interest me. The subject is simple yet theatrical. There is plenty of scope to explore different light and texture effects, and the composition is given some impact by the long view through a doorway to a distant window and focal point. Incidentally, the fluttering curtain was one of those chance happenings that adds to the interest and mood of the picture. A slight breeze caught the curtain for just a few moments, but it was enough for me to notice and I quickly decided that a suggestion of that movement would enliven the composition, helping to lead the eye down to the ground and then along the zig-zag of the floor to the light in the foreground.

Some rooms are full of possible painting subjects. Often when I first see a room, walk round it and view it from various angles, I notice a number of potentially exciting ideas and this might encourage me to paint the same interior from several different viewpoints. In choosing a viewpoint I am also, in effect, making a decision about the basic composition. However, subsequent things I notice, happy accidents (such as the fluttering curtain at Villa Pardini), changes of light or simply the way the painting is progressing, can all influence what I feel about the subject and the sort of qualities I want to bring out. Consequently the composition is never absolutely fixed, but may be subject to modification as the painting develops. Such changes are usually subtle ones and are mostly made intuitively. There comes a point, I think, where the painting composes itself.

Especially with interiors, composition is intrinsically linked with perspective. I will make use of perspective lines and angles to lead the eye into and around a painting, sometimes in quite a dramatic way, as I have done in *Interior, Kuala Lumpur*, reproduced above. Here the acute angles on the right-hand side of the painting sweep far into the distance, focusing on a small area of light before the eye is led, via the curve of the arch, to

THE TERRACE, EVENING,
MENTON, FRANCE
Oil on canvas,
51 x 40.5cm (20 x 16in)

The soft evening light of the
Mediterranean created a
wonderful composition in this
subject. What especially
impressed me was the exact
balance between the closed
shutter and the dark wall on
the right, and the circular
movement of the table and
mirror, which soften the rather
hard lines of the shutter and
shadows on the left.

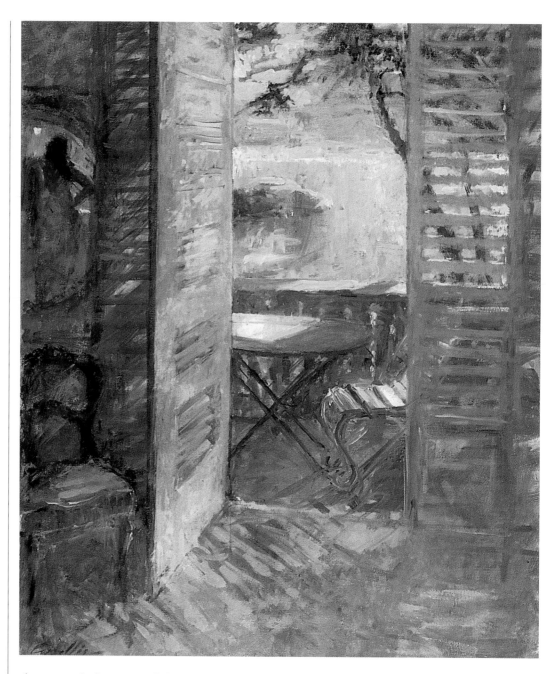

the central, foreground figure. But to work effectively, perspective must be accurately observed and drawn. Usually I make one or two preliminary studies to help me understand the lines and angles involved, and then, working from this information, I can rule some weak perspective guidelines onto the canvas and so construct the correct shapes.

Figures are another useful compositional device, and in an interior they always make a good focal point or centre of interest, as demonstrated in the paintings reproduced on pages 88 and 89. In both of these examples I was able to include a figure actually present in the room, but on other occasions I will use a model, usually my husband or a friend, whom I have persuaded to stand in just the right place! However, I avoid making figures too significant: they have to play their part in the overall composition rather than dominate it. Consequently my treatment of figures is usually quite simple and loose, rather than detailed. Figures also add a sense of scale to a painting. Even so, not every interior needs a

LATE AFTERNOON, MENTON, FRANCE
*Oil on canvas,
102 x 76.5cm (40 x 30in)*

A rather formal composition and an intentional bit of fun, with the knot of the curtain exactly in the centre of the canvas. I did not want a figure in this painting because I wanted the eye to focus on the distant view and not be distracted by too much detail in the room.

figure. As in *The Silk Chairs, Palazzo Contarini Polignac, Venice*, reproduced on page 87, sometimes the inference that someone has just left the room can be equally powerful.

Having found an interesting interior to paint I normally start by making some quick sketches and written notes, because I find this an excellent way of exploring the idea and deciding on the particular qualities I want to emphasize. I may also take some photographs as additional reference. Occasionally I will begin a painting in the studio, working from the location drawings, but in general I prefer to paint entirely on the spot.

With this subject it was just a delight to be there and to paint what was in front of me. The perspective of the pillars and arches had to be studied very carefully, and the shadows moved round all too quickly, so I could only paint this for about an hour at a time over several days.

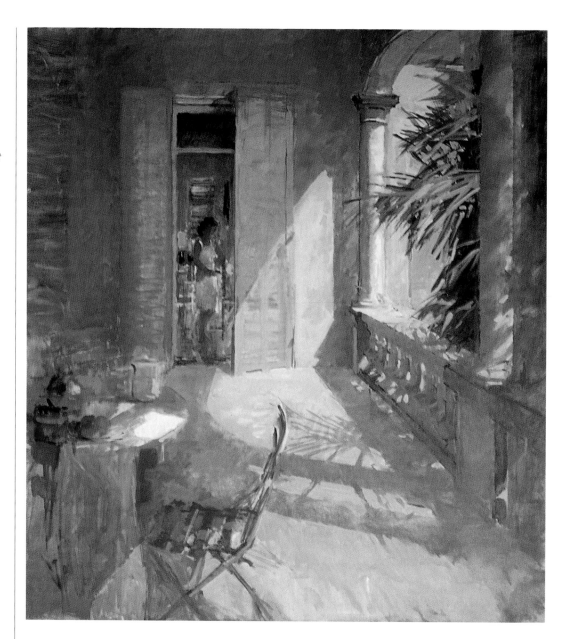

Opposite
LUNCH ON THE TERRACE,
CHÂTEAU MOCQUES, FRANCE
*Oil on canvas,
122 x 91.5cm (48 x 36in)*

My intention here was for a much looser painting with a softer composition. I purposely did not put the strong green light in the centre of the painting, as I wanted to avoid the obvious. I think one has to be very careful about this in composition: sometimes it can work, and sometimes it appears to rely too much on a set formula.

I find that paintings made in the studio nearly always have an unnatural, stilted quality.

Usually I will have all my equipment available nearby in the car, so I can work at a radial easel on whatever size canvas seems appropriate. Apart from a more obvious concern about perspective, my painting method is the same as that used for other subjects. Similarly, I sometimes paint watercolour studies and more resolved watercolours as well as oils, working in a sequence of morning or afternoon sessions to maintain, hopefully, a consistency of light. Because time is limited on such painting trips not every painting gets finished on location. However, by displaying my notes, sketches and photographs around the studio walls for information, and using my memory to transport me back to the interior and its special mood, I find that I can complete whatever finishing touches are necessary in the studio.

Interiors have always been an important part of my work. However, I do find that I paint in phases. Sometimes landscapes or portraits will attract my interest, while on other occasions I will be more involved in interiors or still life.

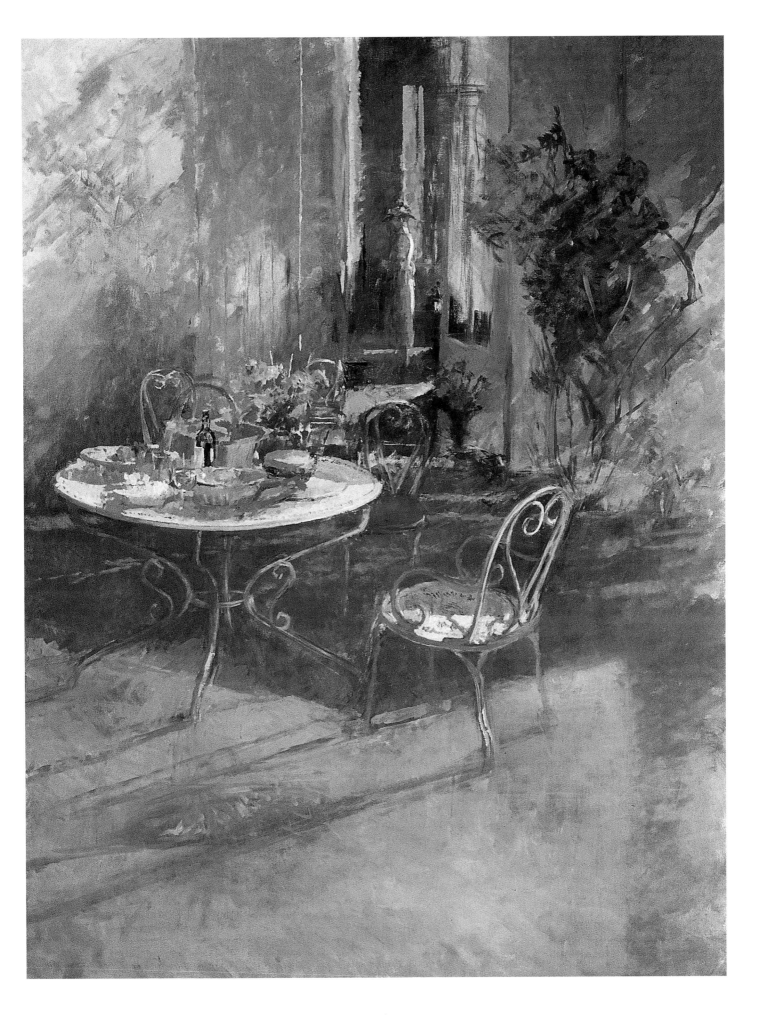

STILL LIFE

I very much enjoy painting still lifes and have been interested in this genre since my school days, despite some initial disappointing experiences! At school, I remember, we had to paint rather boring arrangements, usually of not very appealing objects set up without much thought about composition, light, colour, texture and so on. Even at art school, where I painted a lot of still lifes, more often than not the emphasis was on a closely observed painting or drawing of, say, ovals and rounds and how to convey shape, form and light. So I do not think I was particularly inspired by still life at that stage, and perhaps I was too young and inexperienced to realize that everyday objects could have an inherent beauty.

It was from paintings by Morandi, Zurbaran, Chardin and, of course, Bonnard and Vuillard that I gained my initial interest and inspiration for still life and began to see the possibilities: it did not have to be just an exercise in shapes! What impressed me about Morandi's still lifes was the fact that the precise position of one object in relation to another was of supreme importance. Were an object to be moved a few millimetres either way, then the tension in the composition would be lost. Yet his work, although obviously carefully considered and controlled, has a deceptive simplicity and seems to be expressed in a free, almost haphazard way. There is this enigma, this contradiction in terms.

With Zurbaran, whose wonderful still lifes are often overlooked by art historians in favour of his altarpieces and other religious works, the quality I have always admired is the drama of light – there is a strong theatrical feel about his paintings. In contrast, Bonnard and Vuillard, both colourists, showed me that still life in the form of plates, jugs and everyday items could have a much wider context – could be part of an interior or other view. More recently I have been looking at the still-life paintings of William Nicholson which, with my experience of other still-life artists, have now begun to mean much more to me. They look so simple, yet like Morandi's they are extremely complex and intense paintings.

There are various aims and reasons for painting a still life, I find, and paradoxically (in the light of my remarks about school-day still lifes) one of these is as a sort of exercise. It remains a good way of honing basic skills. In fact this can be quite exciting, and if I run into problems with a landscape, portrait or other work I will often turn to a still life as a means of focusing on drawing shapes, modelling forms or whatever type of problem I am experiencing, subsequently returning with confidence to the original painting. Similarly, I sometimes use still life as a warm-up for another painting or, if for some reason I have got out of touch, as a way of tuning in to painting again. In such cases I usually set out with the intention of making just a small study, but it may well develop into a fully resolved painting.

Equally, still life is a subject area in its own right, offering the opportunity and pleasure

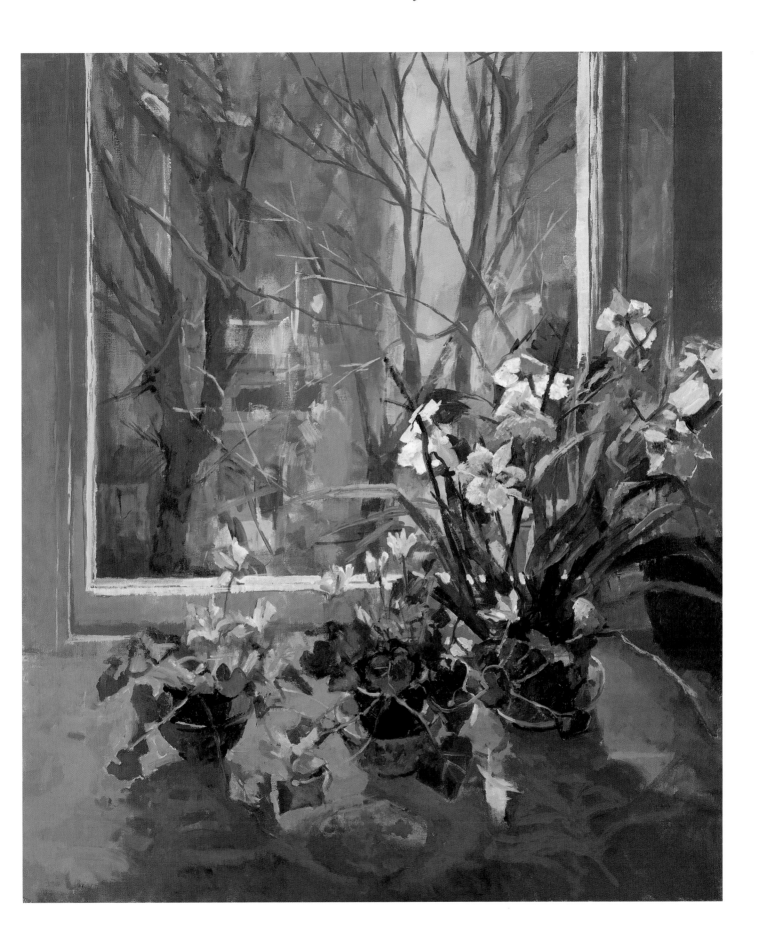

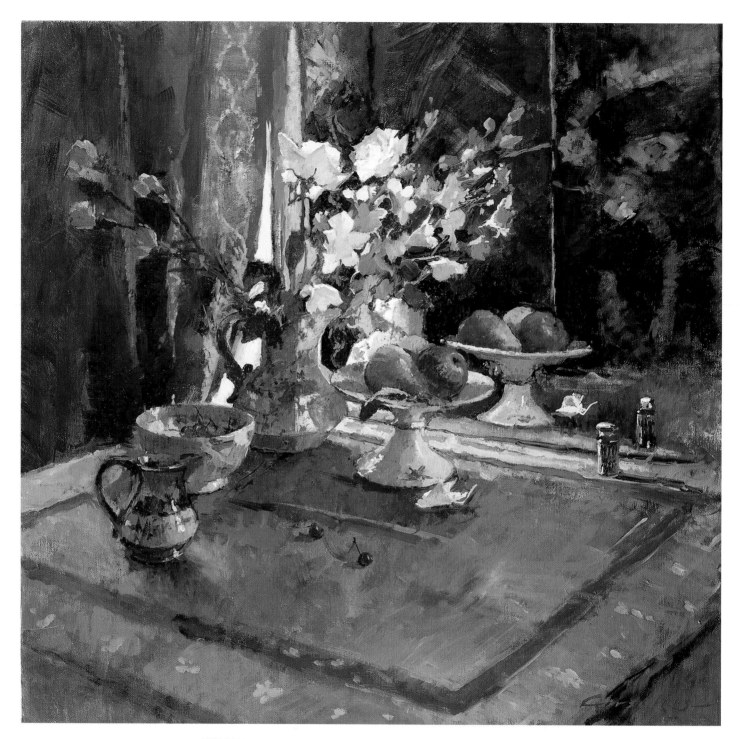

THE ROSE REFLECTED
Oil on canvas, 66 x 66cm (26 x 26in)

*This is another still life arranged in my studio. Here, the light behind
the Kashmiri curtain hanging in front of the window creates a
warm red glow, and I have deliberately arranged the silk cloth so
that the dark stripe would not only encircle the objects on the table
but also help lead the eye up and around the painting. I find such
aspects of composition are all-important when planning a still life.*

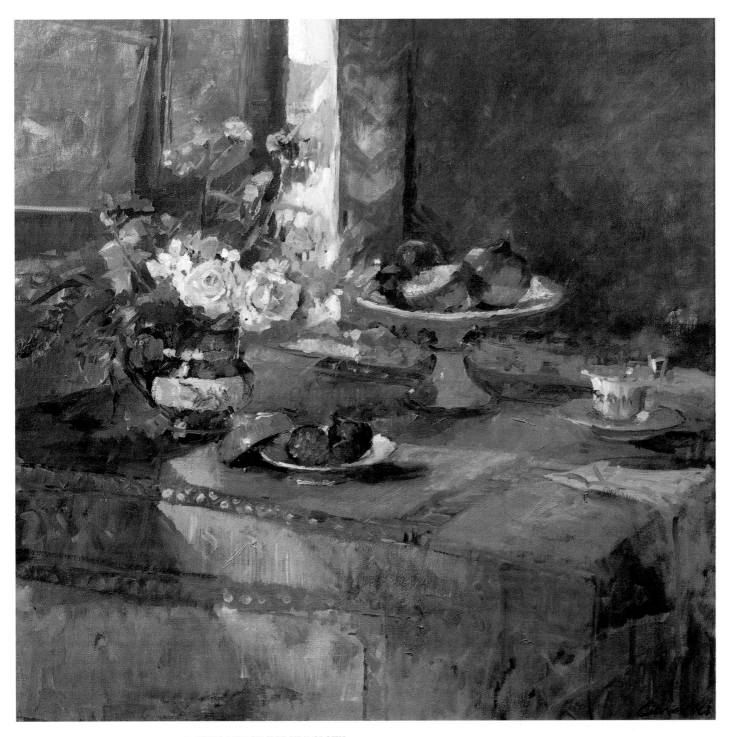

STILL LIFE ON THE SILK CLOTH
Oil on canvas, 61 x 61cm (24 x 24in)

I have a number of favourite things in my still-life collection and paint them over and over again. This painting is on a similar theme to **The Rose Reflected,** *reproduced on the opposite page, but here the light filtered in from the left, just catching the edge of the cloth and highlighting the roses.*

THE EMPIRE BEDROOM, VILLA
MARIA SERENA, MENTON
Oil on canvas,
91.5 x 81.5cm (36 x 32in)

I love painting 'discovered'
still lifes, like this one on a
mantelpiece in the Villa
Maria Serena. What
particularly attracted me here
were the rich, dark patterns
and textures that surround
the mirror, and the contrast
of the reflected interior, which
I enjoyed painting in a light,
free way.

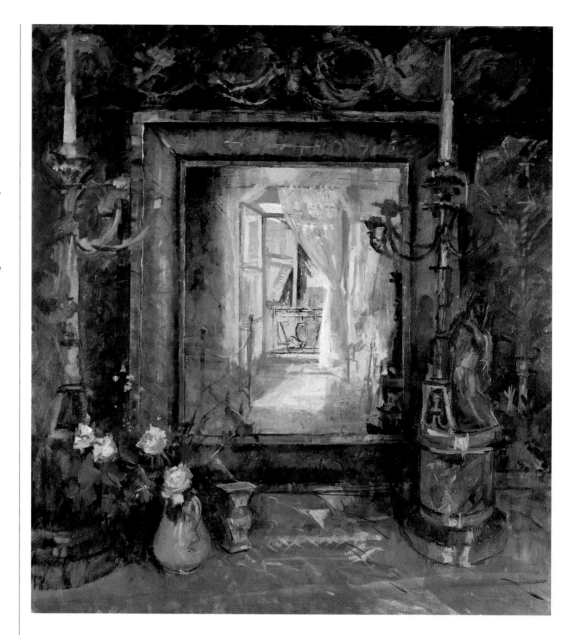

Opposite
PALAZZO INTERIOR, VENICE
Oil on canvas,
86.5 x 61cm (34 x 24in)

This was painted in a large
dark room with heavy silk
wall coverings, so it was
necessary to have the side
lamps on during the day. I
have included the reflected
image of myself in the mirror
because I felt this helped convey
the sense of space and the scale
of the room, and also the
proportions of the huge mirror.

of painting lovely, interesting things. There is an enormous range of possible subjects and ideas, and the treatment can be as austere or as flamboyant as one wishes. Occasionally, for example, I like to paint very carefully, studying every detail, aiming perhaps to capture the texture of a stoneware jar or the transparent delicacy of bone china. Such an approach is in direct contrast with the much freer handling I like to give a landscape or an interior, and obviously there are other contrasts too. For, being an entirely man-made, arranged and controlled subject, a still life has little in common with observing and interpreting nature, and it is the complete opposite of *plein air* painting.

I used to think still life required a more analytical approach than other types of painting, but in fact this is not true because one has to be quite analytical about starting and progressing through any painting. Nevertheless, in a still life it is possible to assemble the objects exactly as you wish and create precisely the required light effects, and in this sense the starting point is a more rigidly composed subject than, say, a landscape. But this need not deny scope for interpretation. As in all painting, in a still life the approach and

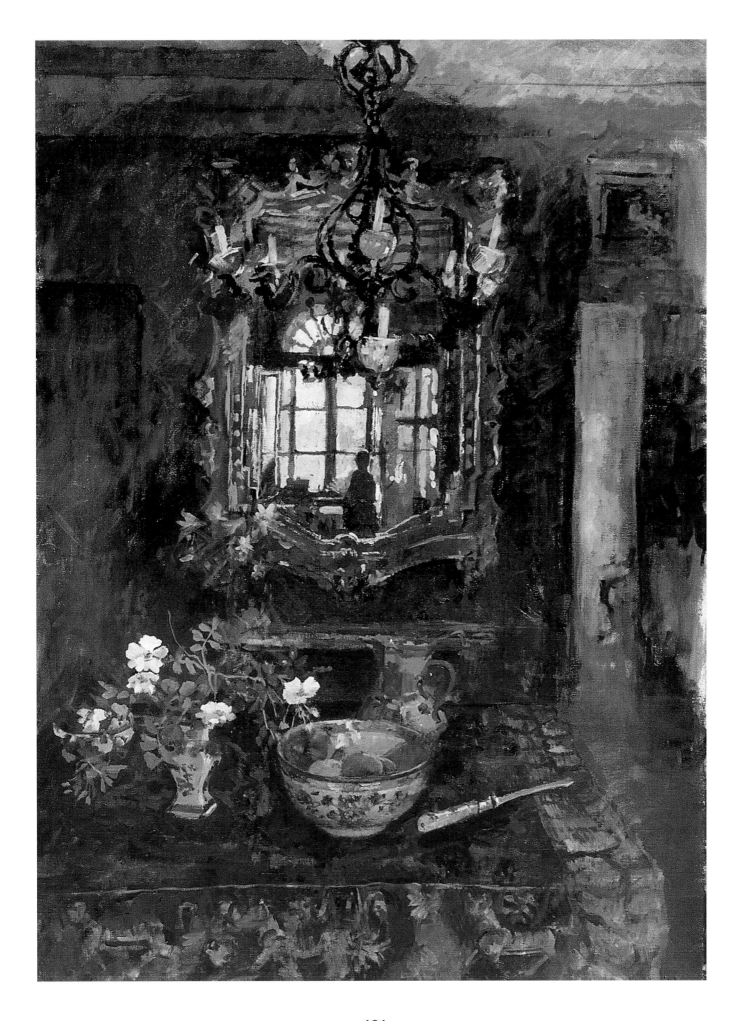

SHADOWS ON THE TOP SHELF
Watercolour,
29 x 51cm (11¹/₂ x 20in)

This watercolour was intended to be a quick exploratory study for the oil painting reproduced on the opposite page. But I became so fascinated with the intriguing shapes created by the shadows on the objects that I carried on with it until it became a finished painting.

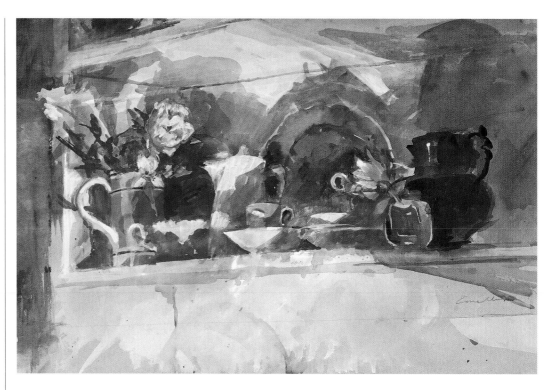

emphasis will depend on those aspects and qualities that seem important, and consequently will give the work a certain mood and impact. However, I feel this happens intuitively rather than intentionally. For instance, I may accentuate shadows, light, the colour key or whatever, but I am not aware of doing this in a deliberately planned way. Instead, I think it is an instinctive response to what I feel about the subject.

Many of my early still lifes were painted as studies with the intention of helping and influencing my other work, which at the time I felt was becoming too free and expressive. I wanted a subject that would demand more in respect of drawing and other essential elements, and still life seemed the obvious choice. Its advantages were that it did not move or change in any way and that it could be left *in situ* and returned to again and again. During my career I have adopted a number of other approaches to still life. From the studies I became more interested in still life first as finished paintings, making their own statement, and then in how they could form part of an interior or larger view. More recently my interest has been in the objects themselves and the effect of light, whether natural or lamplight, and the different ways in which I can interpret this with oils and also in watercolour.

Occasionally I come across a still-life group that is more or less ready to paint – perhaps objects caught in a certain light on the Welsh dresser in my Pembrokeshire cottage, or an interesting arrangement in part of a room somewhere. But this is quite rare, and even when I am struck by a particularly exciting 'found' still life I usually have to make some adjustments. I may need to lower a blind or switch on a light, for example, to enhance the tonal contrasts in the group, or perhaps move something just a fraction in order to balance or enliven the composition. However, most of the still lifes I paint are set up by me, using objects from my large and varied collection.

At home and in my studio I have cupboards full of items I have collected especially for still-life paintings, from striped stones to lustre jars and best Meissen china. Often the guilt factor in acquiring an expensive item forces me into painting a still life, which I

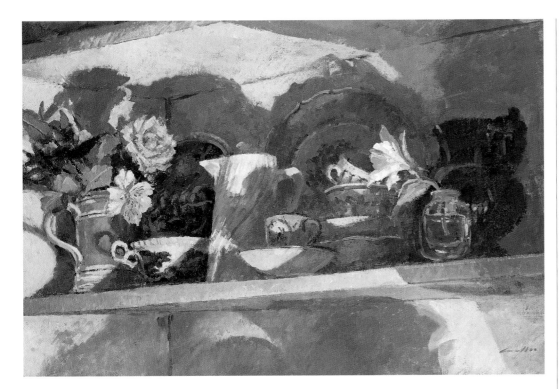

SHADOWS ON THE TOP SHELF
Oil on canvas,
40.5 x 51cm (16 x 20in)

As a development from the watercolour version, reproduced on the opposite page, I decided to move things around slightly in order to make more of the shadow patterns; I also played down some areas, like the dark jug and plate, and brought out others, such as the flowers and cups.

nevertheless always enjoy! But whether I start with something I have just bought or another object that has attracted my interest, I try to build up an exciting group of shapes and forms in which the colours, textures and other qualities enhance or complement those in the original 'key' object. Sometimes I like a really formal composition, balancing colour, tone and shape in a uniform way while still trying to keep everything looking free and uncontrolled. In fact, colour and tone are always important elements to consider, I think. The interplay and relationship of different colours, and the shadows cast by the various objects, whether on each other or on the table, can contribute as significantly to the overall composition as the objects themselves.

The initial inspiration for a still life usually comes from an exciting colour, texture or other characteristic that I have noticed in some flowers or on an object, and this suggests a starting point. Success with still life relies, I believe, on having an empathy with the subject matter and a real enthusiasm for painting it. This so, it is difficult to get good results from an arrangement that you have not set up yourself or that you have simply put together as something to paint. Naturally, there has to be a concern for exciting composition and impact, a genuine involvement with the subject matter, and a strong desire to paint it.

In setting up a still life I often use colour as a means of linking objects, allowing a particular colour to trickle through the composition and provide some unity. As well as the placing and relationship of individual objects, the spaces between them are another important element to consider. These can be useful abstract shapes that balance other areas. Sometimes I will place the objects in front of a window to give a *contre jour* effect and also to create opportunities to relate the still life to an exterior view, perhaps with contrasting light. Similarly, I might combine a still life with an interior view, again taking care that it works as a unified composition and that there are not two conflicting ideas or viewpoints. For really dramatic, controlled lighting effects I arrange the objects inside an open-fronted box, thereby creating a theatrical, stage-set effect.

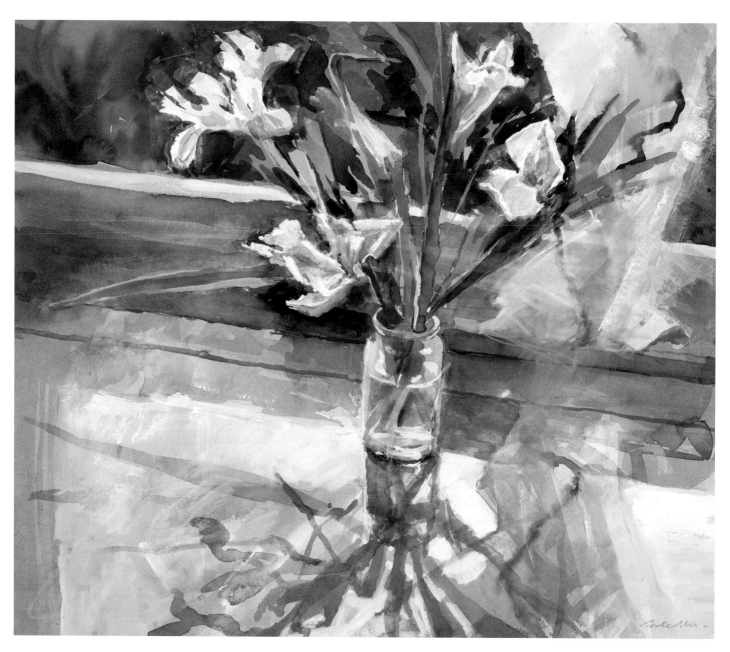

THE WHITE IRIS
Watercolour and body colour,
32 x 37cm (12¹/₂ x 14¹/₂in)

Still lifes do not have to be large
and complicated – a simple
subject like this can also make
an interesting painting. At
first glance this appears to have
a very limited colour range, but
in fact a wide variety of colours
was needed to make the
different whites and greys.

Once the arrangement is resolved I normally make a preliminary drawing, perhaps in the form of a quick charcoal sketch to get the feel of the overall composition, or sometimes as a more careful study of mass, shape and directions. During the drawing I may notice that something could be improved about the composition or lighting, and if so I will make the necessary changes. Even later, when I am painting on the canvas, I like to work with the freedom to move objects or replace them if I wish.

My technique for painting still lifes is broadly similar to the way I paint any other subject, the only difference being that sometimes I have to concentrate on one part of the painting more fully than the rest because of the nature of some of the objects. This is particularly so when flowers and fruit are involved, as these can quickly wilt or deteriorate. Consequently, in order to capture the freshness of flowers and similar items, I may have to do quite a lot of work on them before considering other parts of the still life such as bowls or jugs. However, I try to avoid painting something completely in isolation from

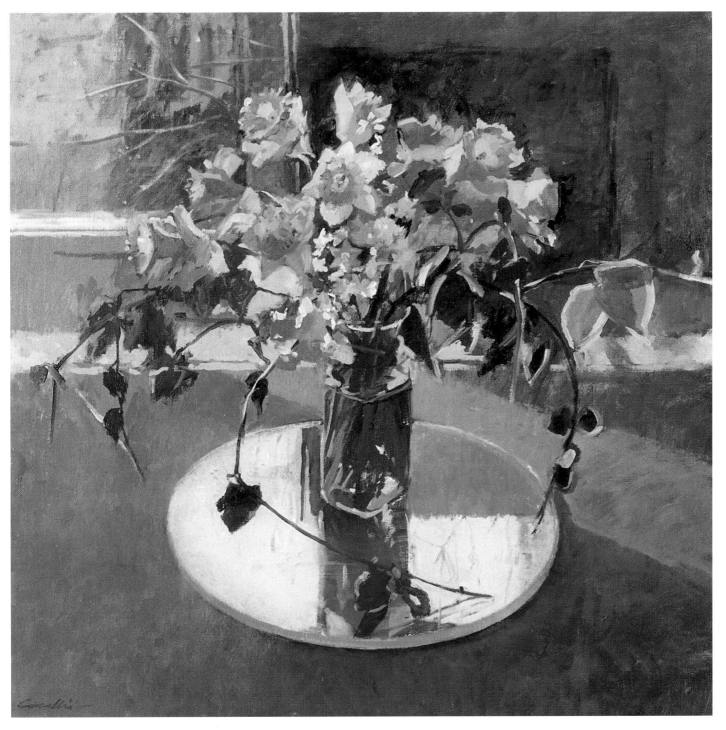

WELSH DAFFODILS
Oil on canvas, 51 x 51cm (20 x 20in)

These daffodils, standing on the glass circle, were full of light and colour, and I added the jonquils and leaves to give a spiky sharpness to the design. Although the vase is placed almost in the centre of the painting, the shapes and shadows of the background counteract this placement.

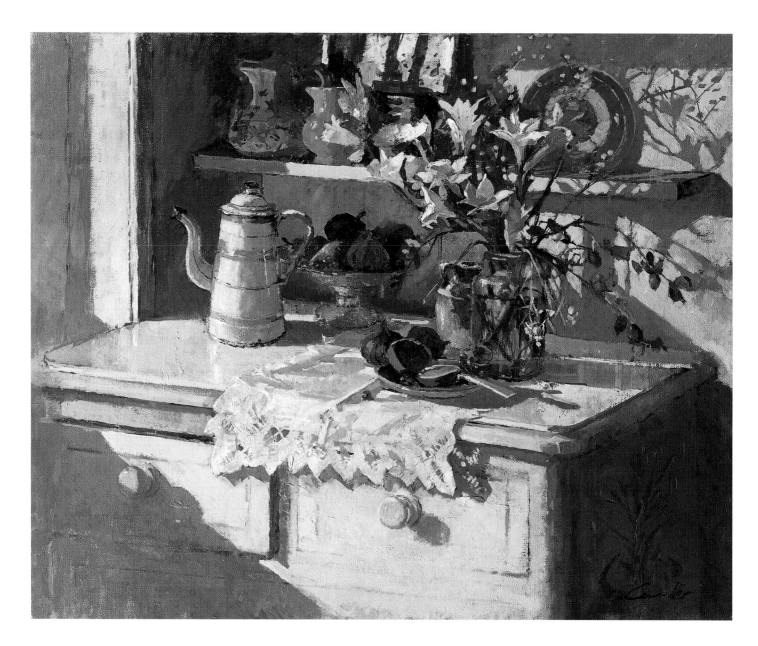

THE WHITE STILL LIFE
Oil on canvas,
66 x 76.5cm (26 x 30in)

This was one of those still-life compositions that needed very little rearranging. It was all there on the white-painted chest – but I could only paint it for a short time each morning before the sun moved and the shadows changed.

its surroundings, because I find ideas work much better if the whole painting is developed at the same pace.

As with my other paintings, I usually start a still life by roughing in the main shapes, perhaps adjusting and redrawing these as the painting progresses. With watercolour I may do a light pencil underdrawing first, but normally I work immediately with light washes. I prefer every aspect of the painting process to contribute to, and be an integral part of, the actual painting, rather than working with outlines and areas which are then simply coloured in. Interestingly, I tend to paint watercolour still lifes very freely, using oils in a more controlled way.

I work with the same basic palette that I use for other subjects, adding to this now and again when I need a very specific colour for one of the objects. My principal concern, as always, is how I can use colour to interpret the particular light and surface qualities, which in turn will reveal something about the objects and give the painting impact. However loosely I paint, my aim is to convey a real sense of the distinctive characteristics of each

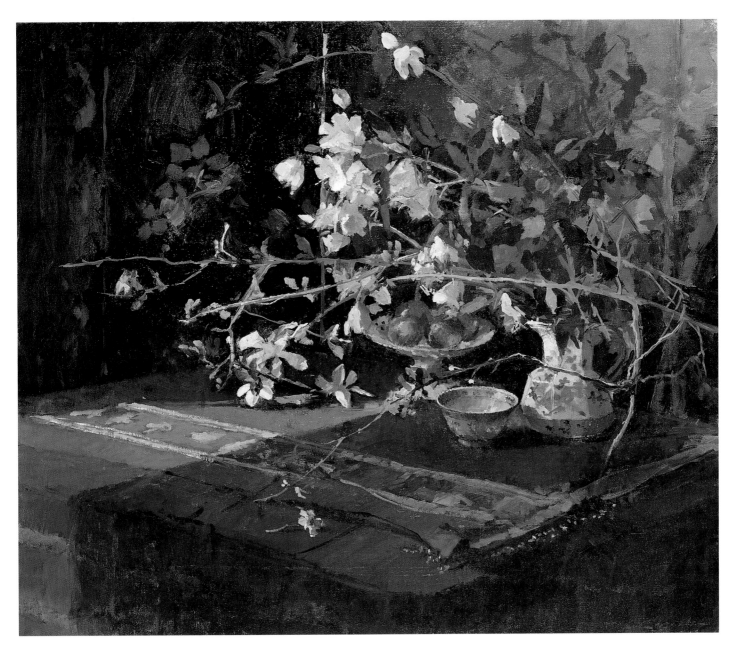

object so that anyone viewing the final painting will be able to 'feel' the stoneware of a jug, for instance, or want to eat a pear. I especially love glass objects because of their obvious reflective quality, and the way in which light can be thrown off in unexpected ways. To my mind, a still life should not be 'clever' or, on the other hand, merely decorative. A good painting, I think, is one in which the relationships of colour, light, form and texture work successfully together to create something exciting and pleasurable to look at.

EASTERN STILL LIFE
Oil on canvas,
71 x 81.5cm (28 x 32in)

This is so called because of the Japanese screen in the background, the Indian cloth, the Chinese bowl and the magnolia – a real mixture. I loved the sweep of the branches across the painting, balanced by the frieze on the cloth.

Chapter Eight

JOURNEYS

I have been fortunate to live in several different parts of the world, and this has offered me some wonderful opportunities to paint in very contrasting cultures, climates and types of light. In fact, since my art school days, travel has been a constant and important influence in my painting. My journeys to Canada, the Far East, India, the USA and parts of Europe have not only provided me with countless ideas and subjects to paint, but have also, in effect, charted my career and development as an artist.

My travels began when I was a student at the Byam Shaw School of Art. The principal at that time was Maurice de Sausmarez, and he and his family used to organize trips to encourage students to study abroad, especially in Italy, in the historic Renaissance cities with their impressive galleries. He used to pile us all into an ancient minibus and once at our destination he would somehow, magically, gain entrance to remote and beautiful villas where the owners would show us their much-loved collections. It was only later that I realized how privileged I had been to see these magnificent paintings in private houses. These expeditions gave me an awareness of the possibilities of working abroad, and I also began to appreciate how stimulating it could be to work within a group of painters.

During the 1960s, sound traditional teaching was already going out of vogue, so I think I was lucky to be taught in what would now be considered a rather old-fashioned way. In my first year I had to make drawings from the cast – that is plaster, life-size models of Greek and Roman sculptures – and I also studied composition and still life. The next year was spent in the life studio, concentrating first on drawing the figure and later on working in oils. However, the final two years were much more liberal and we were encouraged to experiment with methods and the use of different materials. Lithography and general printmaking were part of the course. We were also taught about abstract shapes and their relationship to each other, in both purely abstract paintings and figurative work.

One of the most important things I learned from my student days was that to be a painter one had to have total commitment, and that it is actually a very isolated way of life. I also found that artists need discipline, and it is certainly not the case that you can only paint when the inspiration strikes! In my view, inspiration, enthusiasm or whatever you like to call it only comes about when you start working. Another aspect of my art school studies that has remained valuable is the history of art. I learned about this mostly by going to galleries and museums and looking at real pictures. I had to write a number of essays, and for my National Diploma in Design thesis I chose the Japanese influence on Van Gogh's paintings. The colour and composition in Japanese prints and their influence on Western painting is a subject that has always interested me.

When I left art school I worked for a year in Spain, travelling first to Barcelona and then to Majorca and Ibiza. At that time I was painting mainly abstract works, composed of patches of colour and heavily influenced by Paul Klee. However, as time went on I

PORTRAIT DRAWING
Pencil and wash,
30.5 x 20.5cm (12 x 8in)

A study made when I was a student. I loved the shaded light on the figure, and I was already becoming interested in figures in interiors.

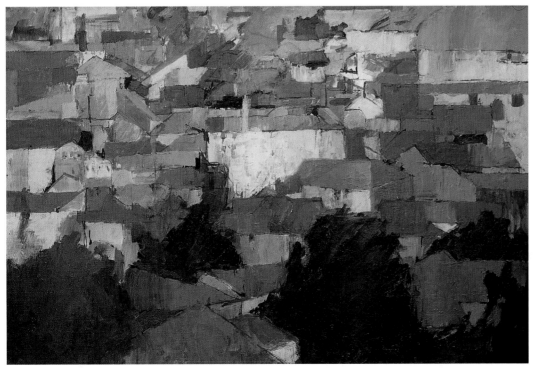

VICENZA
Oil on canvas,
71 x 102cm (28 x 40in)

For this view, with its complicated roof patterns, I kept the shapes simple and applied paint with a palette knife as well as brushes. This was painted on an art school tour to Italy in 1960.

BEACH REFLECTIONS, MALAYSIA
*Watercolour and body colour,
46 x 48.5cm (18 x 19in)*

*This was the exploratory
study for the resolved oil
painting shown on the opposite
page. I liked the way the palm
trees swept diagonally across
the composition.*

started to work more and more from life, painting the subjects around me. But it was a gradual process to find my own voice in painting, for although influences can be very instructive and helpful, they are sometimes difficult to overcome. After leaving art school I always wanted to paint in the style of someone else, usually a painter who was the fashion of the moment, and I think it took me years to shrug off these influences. Now I have come to terms with the way I paint and I accept it as my 'handwriting'. On reflection, I believe the year in Spain was a very important one as far as the development and direction of my work was concerned. It is such a pity that I have only one folder of drawings as a record of that period. Most of the other work was lost on the train home, a salutary experience that has since taught me to take more care with my work – always to carry it with me rather than entrust it to the guard's van or hold.

Back in England I decided to look for a teaching post, subsequently accepting one at Hatfield Grammar School, where I taught for nearly three years. My teaching took up three days a week and the idea was that this would also allow me some time to paint. However, I found that teaching was very demanding and most of my energies were spent on preparing lessons. Eventually there came a time when I had to decide which career I would like to follow and, rewarding as teaching can be, I had no doubt that I wanted to pursue my own painting. Also at this time I married, and shortly afterwards moved with my husband to Germany for six months, then returning to London. During this period I worked hard at building up a collection of paintings to take round to various galleries.

BEACH REFLECTIONS, MALAYSIA
Oil on canvas,
114 x 127.5cm (45 x 50in)

Here I wanted to convey the
humid atmosphere and sea
winds. The umbrellas, which
are shown reflected in the glass
door, were as much for
protection from the wind
as from the sun.

I found this aspect of being an artist a very soul-destroying business, but my husband was extremely supportive and encouraged me to keep painting rather than worrying too much about exhibiting.

The next few years were spent in Hong Kong. By now I had two baby boys and they naturally occupied much of my time, although they did make good subjects for portrait drawings! While we were living in Hong Kong a friend from art school paid us a visit, and she encouraged me to take up painting more seriously again. So I set about finding as many painting commissions as I could. Sometimes I felt like a commercial traveller, going from house to house painting children while the Amah read stories to them, but I really enjoyed it. Just before we left I had an exhibition of the paintings I had done there. The paintings sold well and I returned to England with more confidence.

In 1976 I was elected a member of the New English Art Club and the following year a member of the Royal Society of British Artists. Both these societies were immensely

THE ROYAL VISIT, MALAYSIA
Watercolour,
20.5 x 30.5cm (8 x 12in)

A royal visit was something that just had to be recorded, with all the pageantry and wonderful national costumes. It was especially good to be in the wings and to be able to paint unobserved.

THE ROYAL VISIT, MALAYSIA
Watercolour,
15 x 25.5cm (6 x 10in)

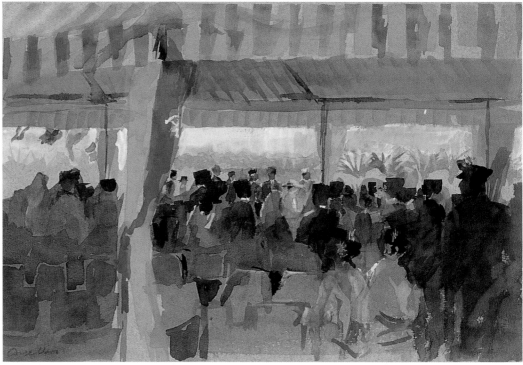

encouraging, and it meant that now I could paint as I wanted. I could focus on creating my best work and, to some extent, not worry about sales. Membership of these prestigious societies also gave my work greater exposure and enabled me to meet other artists who had similar aims and interests. The next significant development in my career was when the New Academy Gallery started to accept my paintings. Without their support I am sure I would not have progressed in the way that I have. They have nurtured me

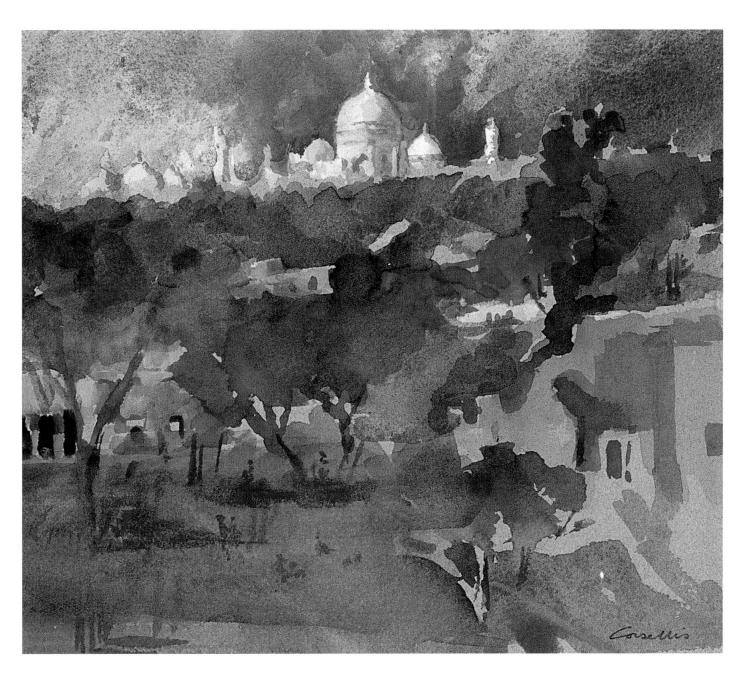

TAJ MAHAL, EVENING
Watercolour and body colour,
15 x 18cm (6 x 7in)

I painted this from the hotel
window. It was a very quick
sketchbook watercolour that
worked out well, maybe
because, as someone once said,
'It can if God happens to be
sitting on your shoulder!'

through the times when I have lacked confidence, and have encouraged me to experiment and develop my work – yet they never tell me what or how to paint. I first showed with them in 1984 when they were the Upstairs Gallery at the Royal Academy, and have exhibited with them regularly ever since.

Our travels resumed in 1979 when my husband was posted to Ottawa in Canada. Here, the thing that most impressed me was the quality of light. It was a strong, clear light that created sharp forms and very obvious shadows. Seeing the landscape lit in this way immediately reminded me of the paintings of Andrew Wyeth, and his work became an influence for a while. The winter landscape was particularly appealing and this was the subject I concentrated on most.

After living in Canada and then London again for a few years, it was quite a shock to discover the strong, uncompromising light and high humidity of Kuala Lumpur, where

FLORENCE, MISTY MORNING
Watercolour and body colour,
25.5 x 34.5cm (10 x 13¹/₂in)

I had seen this view on a previous visit, but I did not have time to paint it. When I returned, I went to great lengths to stay in this particular hotel with this view over Florence, which I painted at different times of the day.

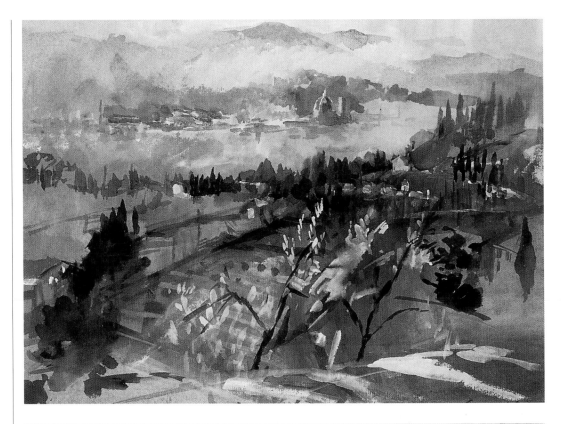

VIEW FROM THE PALAZZO
QUERINI, VENICE
Watercolour and body colour,
28 x 38cm (11 x 15in)

This was painted from the rooftop of a rented apartment in Venice.

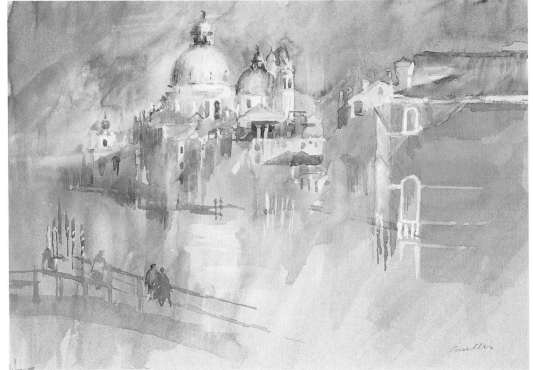

we stayed for nearly three years in the late 1980s. This was a fascinating place and so completely different to anywhere else I had experienced. The humid conditions meant that I had to keep my much-loved hand-made paper in the clothes cupboard, which had a heater to protect the clothes from the damp. I also found that watercolours and oils

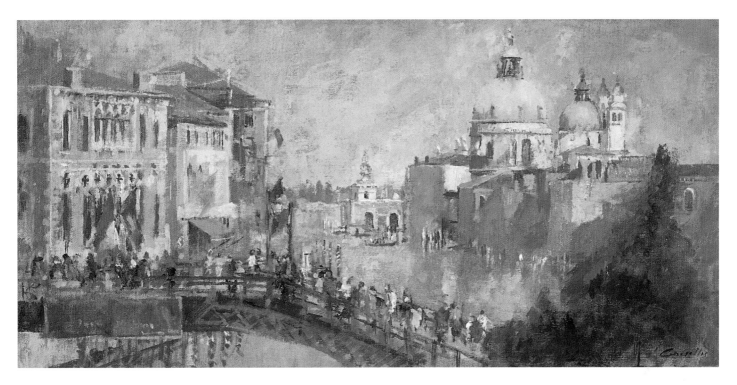

dried quickly, and so I had to adjust my painting technique accordingly. Another difficulty was the lack of good quality canvas, paints and other materials. These could only be acquired on my journeys back to London, from where I would return laden with rolls of canvas and so on. Despite these challenges I really enjoyed my time in Kuala Lumpur, with its wealth of exciting new subjects and opportunities.

In Malaysia the towns and cities were extremely busy, and this made it very difficult and inhibiting to attempt any painting in the streets. So, as I was not inspired by the landscape around Kuala Lumpur, I concentrated mainly on interiors, especially during the first few months of my time there. The town I liked best was Malacca. It had a fascinating mixture of Chinese, Malay and Portuguese architecture, and the interiors were magical, particularly in the old houses, with their interesting wooden shutters and soft primary colours. I was able to stay in Malacca for some time and started a number of interiors there.

Throughout my stay in Malaysia I found it best not to try any changes to my working method or routine and so I continued to paint in both oils and watercolours. For the oil paintings I took a variety of loose stretcher pieces ranging from 35.5cm (14in) to 91.5cm (36in) and several rolls of canvas. Thus, using four of the interchangeable stretcher pieces and a length of canvas, I could make up a stretched canvas of whatever size was required for a particular idea. When I had finished or had worked enough on a painting I would remove it from the set of stretchers which, if necessary, could then be used again for the next canvas.

While living in Kuala Lumpur I made three trips with a group of other painters to India, staying for about a month each time. We flew to Bombay and travelled through Gujarat to Rajasthan, stopping at various locations to sketch and paint. Very hot and dry, India was quite different to the humid and wet climate of Malaysia. On these trips, because everything had to be carried, I limited myself to a pochade box, small panels (canvas laid on board), watercolours and a number of sketchbooks of different weights and colours. Consequently work was confined to small oil paintings, oil studies,

THE FESTIVAL, GRAND CANAL, VENICE
Oil on canvas,
30.5 x 61cm (12 x 24in)

I painted this soon after I had been to see the Tiepolo frescos in the Palazzo Labia. I could not resist all the colour and activity in this scene, which I painted from my room right next to the Academia Bridge.

Above
THE SEINE FROM QUAI ST MICHEL
Canvas laid on board, 25.5 x 30.5cm (10 x 12in)

Opposite
NOTRE DAME, SUNRISE
Oil on canvas, 30.5 x 25.5cm (12 x 10in)

For this view along the Seine, showing bridge after bridge in the morning light, I used a small canvas-covered board, completing all the work on the spot. Paris, like many large cities, is full of interesting subjects to paint. On this particular trip I painted various views of the river, worked in the Tuileries and Luxembourg Gardens, and also did a number of cityscapes. As with the painting shown above, these were mostly small oil paintings completed on site. This is the best way to understand and capture the essence and mood of a subject, I think.

When staying in any city the location of the hotel is always an important point to consider, I have found, for a great deal of time can be wasted travelling to and from the subjects one wants to paint. In Paris I was lucky to find a perfectly placed hotel from which I could watch the wonderful dawns over Notre Dame. Clothed in scaffolding, in dawn light, contre jour, *this magnificent building took on a lovely spiky silhouette.*

DAWN, PARIS
Watercolour,
25.5 x 12.5cm (10 x 5in)

A quick study to catch the early morning walker. I think I just took the first sheet of paper that came to hand, but I really like the odd shapes and composition.

watercolours, and drawings and sketches which could be used as preparatory work and reference information later. I was very aware that I would not have a chance to return to these subjects and locations again so it was essential to record as much information as possible.

In addition to the sketches and studies, I took plenty of photographs. These proved invaluable when, much later back in the London studio, I wanted to develop several of the ideas as more resolved paintings. Photographs may not show the subtleties of a subject, but they often record something that might easily be overlooked in a sketch, especially when time is limited. One of the great problems in India was the interest we created while painting. However, we had a very good guide who would find us reasonably quiet places to paint, such as on a Land Rover roof! Sometimes he would even organize a group of boys with sticks to keep everyone at bay! The painting subjects were limitless and I did a lot of paintings of the Pushkar camel fair, of interiors, landscapes and other subjects.

Returning to the UK was like discovering Europe all over again. I became aware of the clear light and I soon decided to make another trip to France and Italy. I stayed in Paris for nearly a month. By now I had become far more selective about my choice of hotel, because I had discovered that an awful lot of time can be wasted travelling around the city to the best painting locations. The hotel I found was perfect, despite the fact that the whole of the Paris traffic seemed to be rushing through the room all day and night! However, the plus side was that the noise of the traffic woke me up each day at 5am in time to see the wonderful dawns over Notre Dame. I painted the river from the hotel, painted in the Tuileries and Luxembourg Gardens, and also did a number of cityscapes. These were mostly oil paintings completed on site. I enjoy painting in large cities because there is always plenty of interesting subject matter, and so many other things to do when the day's painting is finished. This is especially true in Paris, which has fine museums and galleries to visit as well as peaceful parks and gardens in which to wander.

When I travel on the Continent I usually take our 'people-carrier' car, which is large enough to transport all my materials and equipment and can also be used as a sort of travelling studio. In Italy I visited Florence, Lucca and Venice. Numerous artists have painted Venice, of course, but I think you have to forget about that and, like any other subject, try to see it and interpret it in your own way. There is enough inspiration there for everyone! Again, it was the light that made subjects interesting for me, especially when I started painting interiors. I also enjoyed painting night scenes. The Venice night life is surprisingly colourful and theatrical, as I have tried to show in *The Bridge of Sighs at Night, Venice*, reproduced on page 124.

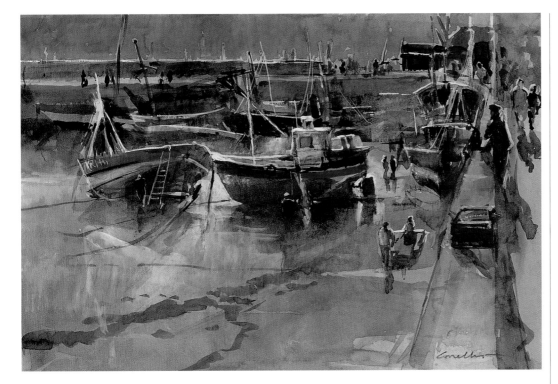

THE HARBOUR, ERQUY
*Watercolour and body colour,
23 x 33cm (9 x 13in)*

I painted this contre jour,
*and by positioning the harbour
wall horizontally at the top
of the painting I thought it
would make a very striking
'L'-shaped composition.*

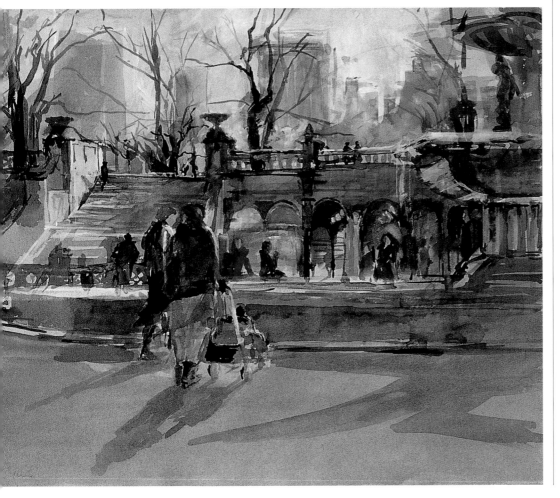

THE BETHESDA FOUNTAIN,
NEW YORK
*Watercolour,
35.5 x 43cm (14 x 17in)*

*This was one of the paintings I
made on my trip to New York
in February 1999. I wanted to
see the city in the winter and
had hoped for snow. While I
was unlucky with the snow, I
nevertheless enjoyed painting
in the winter light, especially
in Central Park. The fountain,
which is in the centre of the
park, is a place where mothers
and children meet every day.
The foreground shadow in the
painting is from the wings of
the statue above, the Angel of
the Waters.*

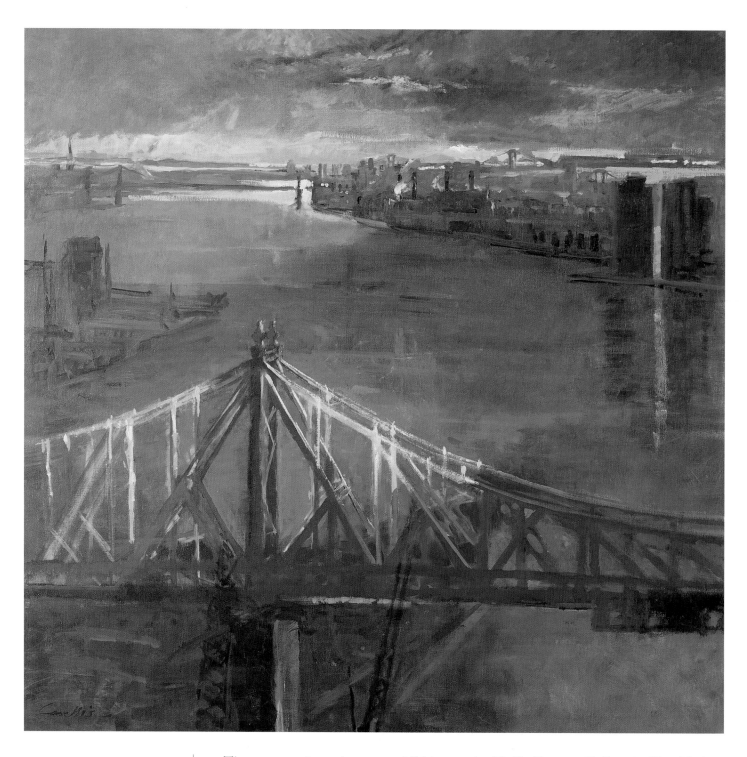

The opportunity to have an exhibition at the Hollis Taggart Gallery in New York in the autumn of 1998 encouraged me to spend some time painting in New York city and on Long Island. Initially, I must admit, the prospect of working in another large city seemed rather ill-timed just then, as I had recently started a series of paintings in Wales. But I was instantly impressed by New York: it was exciting and invigorating.

My first visit was in September. I had no preconceived ideas about what I would paint, deciding that I would go and then search out possible subjects once I was there. We stayed in the wonderfully old-fashioned Wyndham Hotel, which was quite near

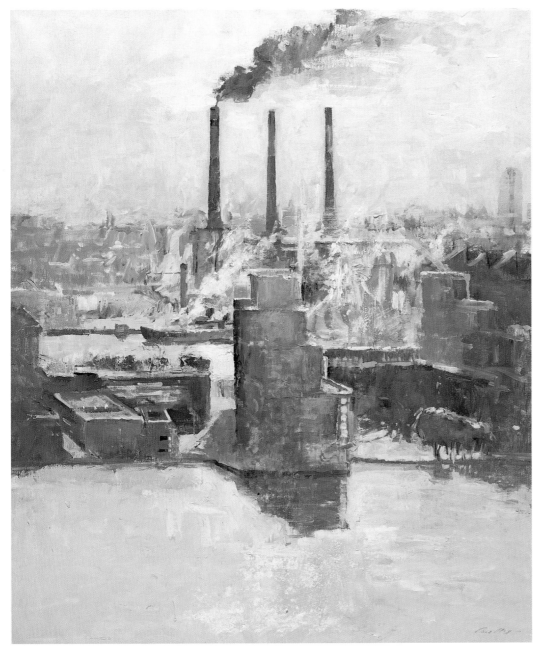

SMOKE AND GOLDEN LIGHT,
EAST RIVER, NEW YORK
*Oil on canvas,
76.5 x 63.5cm (30 x 25in)*

The Con Edison Power Station has these three magnificent chimneys which are a landmark of the East River. There was something about all this energy, contrasting with the simple shapes against the light, that was irresistible.

Opposite
EVENING SKY, EAST RIVER
*Oil on canvas,
122 x 122cm (48 x 48in)*

This was painted from a top-floor apartment which had this unique view right down the river almost to Kennedy Airport. As is so special to New York, the play of the evening light lost and defined buildings in an exciting way.

Central Park. It was the height of the tourist season, hot and sunny, and just amazing to have the opportunity to explore the city as much as possible. I spent a lot of time in Central Park watching the world go by, and this was invaluable as it gave me the chance to take in the atmosphere of the park and to notice the unique quality of the light. Because the buildings are so high the shadows seem really dark, darker than in, say, Hyde Park, with the light appearing as shafts between each block and being reflected in, or bouncing off the windows in a totally unexpected way. I started planning the triptych painting *Central Park, September*, reproduced on pages 122 and 123, during this visit. I painted three small panels in my pochade box, setting them up alongside drawings and tonal sketches in my hotel room – to the amusement of the hotel maid, who showed much interest and made some useful suggestions.

The next visit was in February. This time I wanted to see the city in winter. I had

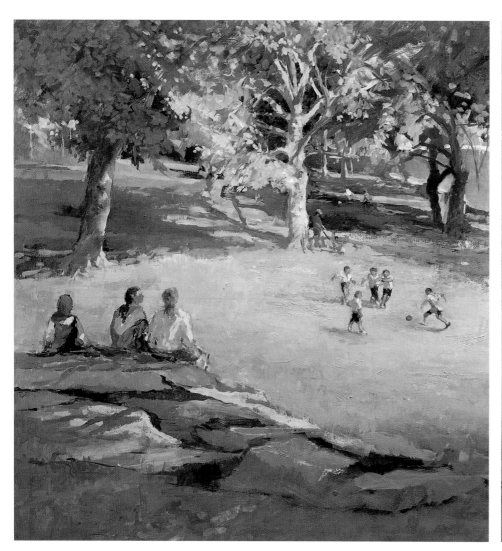

hoped for snow, but this was not to be. Nevertheless, the park was exciting and the bare trees and shadows were just what I had been looking for. There is something very special about a city in winter. The people in the park really want to be there despite the cold, and the mothers and children walk there every day. I saw the same families day after day round the Bethesda Fountain and on the Ice Rink, and began to feel involved in the way of life of a particular community. For this visit, as I was on my own, I rented a studio flat on the top floor of a house on the west side of the park. Here I was able to work undisturbed for as long as I wanted. Brushes were the only item of equipment I took with me, as everything else could easily be bought once there. Brushes are a very personal item to a painter: familiar brushes are essential.

It was particularly enjoyable to make sketches of the horses and carriages in the evening light as they waited beneath the flags of the Plaza Hotel. However, I did not work all the time. I did manage a few evenings at Carnegie Hall, the 'Met' and the Oak Room at the Plaza! I also spent some time in the Metropolitan Museum, where I became interested in the people looking at objects inside the glass cases. I thought this would make a good subject for a painting. At first I considered a still-life painting of the vases *in situ*, but then I think the idea was subconsciously influenced by Vuillard's *The Salle Clarac*. I liked the shapes of the Greek and Roman vases and the geometric qualities of the

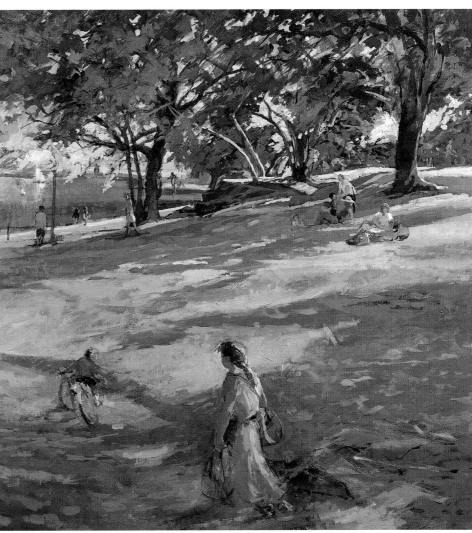

design, both in the objects and in the overall composition of the subject. While I was not allowed to use watercolour in the museum, for some reason there was no objection to oil colour. So I made several small studies discreetly behind the lid of my pochade box, using these later in the studio as the reference for the oil painting *Interior, Metropolitan Museum, New York*, which is reproduced on page 7.

I was unlucky with the snow. However, I decided to return to New York in the spring, in blossom time. It was then that I met a friend who generously allowed me to use her apartment on the upper floor of a block overlooking the East River, with Queensboro Bridge, Brooklyn Bridge and Kennedy Airport in the distance. On one side there was a marvellous view down the river, and on the other side I could see the smoking chimneys of the Con Edison building in Queens, Long Island, all yellow and gold with contrasting blue/purple smoke and shadows. Later I had more good fortune when another family lent me a house on Shelter Island, Long Island. I was keen to explore the landscape and beaches here and had hoped for sunshine and calm waters, but I arrived just after hurricane Bonnie had devastated much of the East Coast. However, I was able to do some painting on site, even though the wind blew sand into the paint and created some additional interesting textures!

For many years I have had a studio in our house in west London, and for the past ten years I have also had a separate studio nearby. London is my necessary evil. I long to leave

CENTRAL PARK, SEPTEMBER
Oil on canvas,
96.5 x 268cm (38 x 106in)

This painting was a celebration of the park and I wanted to paint all the activities that were going on around me. Therefore I had to be very careful with the composition, making sure it did not become a confusing jumble. The three canvases are linked by various means but, as with all my triptychs, they can also be viewed as separate pictures.

it for the tranquility of the country, yet when I am away I miss the stimulation of the galleries, theatres and general city life. However, as I also have a house in Wales, I am exceptionally lucky in being able to enjoy the best of both worlds. There is much to paint in the city, but for a long time I failed to appreciate this. Instead I was much too keen to get to Italy, France or back to Wales. Finally, a silent rebellion in the family at being left on their own so much made me realize that there were just as many exciting subjects on my own doorstep, if I could but see them.

At about that time I received a commission to paint for the new Capital Club in the

City. They wanted a series of paintings of the royal parks to hang in their dining room and also a painting of the City. I decided to paint the Mansion House from the steps of the Royal Exchange. Although I like to paint street scenes from time to time, I much prefer the park landscapes. I suppose these are as close as one can get to countryside in the city, and I love the atmosphere there. The River Thames is another subject that I feel an affinity for, and I have painted it from Chiswick to the Isle of Dogs many times.

I have lived in Pembrokeshire for about 40 years. My parents bought a small house on the coast when I was a child and all our holidays were spent there. It was just a wooden building set above the beach and I remember it as always being bitterly cold and damp during the winter. But over the years we have made it weatherproof and comfortable, and now we are able to spend more time there. I always enjoy returning to that area: the landscape is particularly beautiful at every time of the year and in all types of weather, and there is an infinite variety of subjects to paint. The isolation in the winter, when I have painted the hills and rivers in the snow, contrasts wonderfully with the busy family holidays on the beaches in the summer, when there are colourful regattas to paint. I am also particularly lucky to have the Nevern estuary nearby. This is a constant source of subject matter, with its ever-changing tide patterns, light and wildlife.

One of the benefits of returning to a place is that it enables you to see familiar things afresh. For example, I had never been especially interested in the cliffs around Fishguard Bay, but seeing them in a particular light one evening inspired me to begin a new series of

FIREWORKS ON NEW YEAR'S
EVE, 2000
Watercolour and body colour,
53 x 74cm (21 x 29in)

A view from the Tower of
London painted in watercolour
diluted with champagne!

Opposite
THE BRIDGE OF SIGHS AT NIGHT,
VENICE
Oil on canvas,
61 x 61cm (24 x 24in)

This is Venice at its most
theatrical. I painted a number
of watercolour sketches by the
light from the street lamps and
used these later as the reference
for this oil painting.

125

PWLLGWAELOD BEACH,
PEMBROKESHIRE
Oil on canvas,
91.5 x 91.5cm (36 x 36in)

I liked the way the solitary
figure seemed to emphasize the
scale and grandeur of this
isolated and peaceful place.

cliff paintings, and *Pwllgwaelod Beach*, reproduced above, is one of these.

Wherever I have painted, I have always felt that it was the special quality of light that gave the subject its interest and impact. However, while painting has a lot to do with noticing and, through constant practice, understanding light, colour, shape, texture and so on, I believe it must also involve something of the artist – an individual interpretation and method of working. My aim in this book has been to show how I work – my personal view of painting. It is, of course, just one of an infinite number of approaches. But I hope you have found it an interesting one, and have enjoyed discovering what painting means to me.

ACKNOWLEDGEMENTS

I should like to thank all those who have helped and encouraged me, especially my family and John and Jill Hutchings of the New Academy and Business Art Gallery, who have exhibited my work for nearly twenty years. Thanks also to all the other galleries who have shown my work, particularly Richard Hagen, Andrew Kimpton and Bill Patterson.

I could not have attempted this book without the support of Robin Capon, whose patience and skill was absolutely invaluable. I should also like to thank Roy Fox and John Ross for their excellent photography, Lenny Villa for his wonderful frames, and my generous new friends in New York, particularly Jay and Judy Inglis and Josie Patten. Finally, my grateful thanks to all those people who have bought my pictures over the years and to those who have allowed me to have them photographed for this book.

A 60-minute film with Jane Corsellis is available on video from APV Films, 6 Alexandra Square, Chipping Norton, Oxon, Tel: 01608 641798.

INDEX